Lockdown Chronicles

"I hope that we will not only end this in a wholesome place, but we will find truths barricaded in the fragile parts of our being." Joyce

"I proceed in the hope that we will find a way to keep this river of thought flowing long into the future." Eric

LOCKDOWN CHRONICLES
A Journey through Memory

Joyce Ashuntantang
Eric Chinje

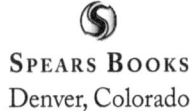

SPEARS BOOKS
Denver, Colorado

Spears Books
An Imprint of Spears Media Press LLC
7830 W. Alameda Ave, Suite 103-247
Denver, CO 80226
United States of America

First Published in the United States of America in 2024 by Spears Books
www.spearsbooks.org
info@spearsmedia.com
Information on this title: www.spearsbooks.org/lockdown-chronicles
© 2024 Ashuntantang & Chinje
All rights reserved.

No part of this publication may be reproduced, distributed, or transmitted in any form or by any means, including photocopying, recording, or other electronic or mechanical methods, without the prior written permission of the publisher, except in the case of brief quotations embodied in critical reviews and certain other noncommercial uses permitted by copyright law. For permission requests, write to the publisher, addressed "Attention: Permissions Coordinator," at the above address.

ISBN: 9781957296364 (Paperback)
ISBN: 9781957296371 (Ebook)

Spears Media Press has no responsibility for the persistence or accuracy of urls for external or third-party internet websites referred to in this publication, and does not guarantee that any content on such websites is, or will remain, accurate or appropriate.

Designed and typeset by Spears Media Press LLC
Cover designed by D. Kambem

Distributed globally by African Books Collective (ABC)
www.africanbookscollective.com

To the blessed memory of Irene Bih Chinje, the twin sister of Eric Chinje (September 8th, 1954 - July 16th, 2024).

We dedicate this work to you, Irene, to memorialize your earthly life. Even though you may not now be here to hold this book in your hand physically, you touched its making since your beautiful spirit hovered over and around us as we finalized the work for publication.
Have eternal peace!

Contents

Prelude	vii
Letter 1	1
Reply to Letter 1	15
Letter 2	25
Reply to Letter 2	33
Letter 3	47
Reply to Letter 3	57
Letter 4	69
Reply to Letter 4	89
Letter 5	101
Reply to Letter 5	113
Postlude	123
About the Authors	128

Prelude

The 21st century will be remembered more for 2020 and the COVID-19 pandemic than anything else in human history, particularly in the world's most powerful nations. Yes, time stopped, or so it seemed, in the United States of America, China, the United Kingdom, Italy, and beyond! Life took a prolonged pause, and the whole human family was forced into profound introspection, both individually and collectively.

I vividly remember that year, as does my friend Joyce. We remember the long days, weeks, and months filled with silence and inactivity! We remember how, in our long silences, we were thrown into extended moments of deep reflection on life – the purpose of life – and our human condition. We got to talking about it, and the idea of the "Lockdown Chronicles" emerged from our occasional phone conversations, stemming from the inability to envision an in-person meeting.

I had just returned from a trip to India, flying into Washington-Dulles airport on March 3, 2020, on a flight

from Delhi. There was nothing unusual about the flight or the ride home from the airport. The cab driver mentioned something vague about issues related to flights from abroad but could not provide specific details. He was a nice guy, and despite being tired and disinterested in the subject, I felt compelled to maintain the conversation with him. I remarked that the weather was better than I'd expected. He agreed that I had picked a good day to fly in, mentioning that the weather had not been this good lately! I got home, and when I turned on the T.V., I understood what the cab driver had tried to tell me when he picked me up. The news about COVID-19 from China was becoming a frightening specter worldwide. In fact, on that day, the CDC reported 60 cases of COVID-19 across Arizona, California, Florida, Georgia, Illinois, Massachusetts, New Hampshire, New York, Oregon, Rhode Island, Washington, and Wisconsin. Of the 60 COVID-19 infections detected, 21 were travel-related, 11 resulted from person-to-person spread, and 27 were of unknown origins.

Around that same time, as an invited poet, Joyce was waiting excitedly to attend the 24th edition of the international festival "Curtea de Arges, Poetry Nights" in Romania. The organizers slated the festival in June, barely two months away. She was glad to see her poems translated into Romanian, which meant a new set of readers would enjoy her poetry in their preferred language. She was expanding her reading audience, and feeling happy. Moreover, the National Translation Center

in Egypt had recently acquired the rights to her poetry collection, *Beautiful Fire*, and the Egyptian poet, Amal Gamal was set to finalize the translation of the collection for publication. However, on March 11, after more than 118,000 cases in 114 countries and 4,291 deaths, the World Health Organization (WHO) declared COVID-19 a pandemic. Joyce was scrambling to convince her older son David to return home from Europe, where he had been trying out for one last chance for top-level soccer teams before heading to law school. He successfully made it home on March 13, coinciding with the Trump Administration's declaration of a nationwide emergency and imposition of an additional travel ban on non-U.S. citizens from 26 European countries.

By March 15, 2020, U.S. states began implementing shutdowns to curb the spread of COVID-19. The New York City public school system, the largest in the U.S., with 1.1 million students, closed its doors, while Ohio mandated the closure of restaurants and bars. Almost overnight, we found ourselves gradually confined to our homes.

There was no escape from the existential questions that tormented our minds. Aloud, we asked, "Where are you, God?" We attempted to peer through the window into eternity, into God's mind. We talked to God directly: "Is COVID-19 another manifestation of the awesomeness of your power? Can you bring it all to an end in one fell swoop?" We heard the echo of our voices as we wondered what would become of our world. In the early

days of the pandemic, journalists relied on historians to provide a sense of direction based on past pandemics.

We felt helpless as we waited for scientists to find a vaccine. In that void, we reassessed our mortality and contemplated the relevance of all the teachings of celebrated prophets. We thought, "This was the time for the revered men of God to shine," yet, where were they? I believed it was their opportunity to illuminate the existential questions that plagued us, and I shared this perspective with my friend, Joyce.

Time stood still. In Cameroon and other African countries, the situation was different. The concept of a lockdown or social distancing seemed impractical and defied reality. While schools and some church gatherings were temporarily closed, people soon resumed their daily activities. We watched with consternation and fear, yet each passing day proved that Africa's response to COVID was going to be different. In the United States, the lockdown was a tangible reality.

Perhaps it was the boredom from the lockdown or the way of dealing with the questions that were swirling inside us, but three months into the lockdown, Joyce and I decided to confront our thoughts through letters. However, once we started writing, the letters took on a life of their own. Between July 4, 2020, and August 27, 2021, we exchanged over 26,000 words in ten letters, with five from each of us. We soon realized that the letters forced us to relive the past from the vantage point of the present. We reflected on our relationship with

God and religion, delving into pockets of childhood and adolescence to understand some of our adult behaviors. We re-evaluated memorable moments of adulthood and questioned certain practices we had come to accept. In one of her letters, Joyce seemed to have anticipated this range of introspection when she said, "I hope that we will not only end this in a wholesome place, but we will find truths barricaded in the fragile parts of our being."

I could not agree more. Nevertheless, our initial idea was not to publish these letters. They served their purpose when we wrote them, and that was it. Then, in 2023, Joyce and I experienced a different kind of lockdown. She was diagnosed with breast cancer and underwent seven months of intensive treatment, while I, on the other hand, had aorta aneurysm surgery.

While in our respective recoveries, we engaged in numerous conversations and took the opportunity to revisit "The COVID Letters," as we affectionately called them at the time. It was at this point that we recognized that these letters captured a fragment of our response to the COVID-19 pandemic lockdown, prompting us to consider adding them to the collective memory of the pandemic. We decided not to revise the letters and to publish them as we originally wrote them.

In the aftermath of the lockdown, many countries have made various attempts to collect stories of the pandemic from diverse groups, including frontline workers, families, students, and patients. These stories provide valuable insights for the future. Therefore, people worldwide

must document their stories about life during the pandemic to have what Achebe calls "a balance of stories."

The pandemic catapulted the world into an existential crisis, prompting a collective reckoning with our values and purpose. As you sift through these letters, we hope you discover much more including re-evaluating your own values and purpose.

Stay blessed and may the COVID-19 experience continue to move us toward a better understanding of our world.

Eric Chinje

Letter 1

July 4, 2020

My dear Eric,

Where do I begin to answer the question you leveled at me/our community this afternoon? You are right, in this COVID-19 era, we need some answers from our religious leaders, politicians, intellectuals, and elite. But as you rightly say, you are not looking for answers per se but a reinterpretation of our world. You think a time like this calls for such reinterpretation from different angles. However, I believe that each individual must engage with the moment to make sense of it. For example, how is this COVID-19 era forcing me to confront my religion, and what new conclusions am I drawing from this period? I will attempt to answer that question but that would mean going back in time to retrace my journey as a Christian.

To be honest with you, my relationship with Christianity has been a complex one for some time now, especially during my sojourn abroad. I have had more questions than answers. Many times, I have found the Bible wanting as a black person and as a woman. Thus, many times in church, I am not anchored by faith, and

other times I am gripped by the age-old religious fervor, even crying while singing certain songs about a white Jesus removed from my immediate community.

I was born into a Presbyterian family and so became a Presbyterian by faith. I did not have a choice in the matter, although I was not baptized as an infant. When I was born the 5th child, my father was busy preparing to leave Cameroon for further studies in England. He left when I was two months old and my mother remained behind, saddled with five young children. I have over fifty pieces of mail from my mother to my Dad covering the first two years of his absence. The letters speak of excruciating financial hardship and the difficulty of taking care of children as she was also a student at St Francis Teacher Training College, Kumba. Thus, I am not surprised that baptizing me took a back seat, and she eventually left me at the age of two with her older sister as she joined my father in England.

My parents returned to Cameroon in 1972 and resumed their employment with the Presbyterian mission. They were posted to Presbyterian Secondary School Besongabang. My father was the vice Principal and my mom a tutor. I was six at this time and became an ardent Sunday school pupil. That year, I went on stage for the very first time with my memory verse, John 11: 35, "Jesus Wept."

The sixth and last child was born in 1973. Her birth signaled my parents' effective return to Cameroon. We were now living in Buea. I grew into a young fervent

Christian. Besides Sunday school, my immediate older sister Emilia and I joined the Young Presbyterians (YP), an active youth group of the Presbyterian church. We became young Christian stars in Sunday school and YP, acting in church plays and conducting the youth choirs during competitions and regional church rallies. On October 31, 1977, Emilia, who was in Form 1 in GHS Mamfe, drowned. A part of me died with her. I was 11 years old. When it was time for her to be buried, I heard the adults whispering that she would not have a cross on her grave because she was not baptized. I could not understand that. Emilia was an exemplary young person. She had been a young church leader from the tender age of 10 so why would she not have a cross? I did not understand it. I could see that my father was hurt. That is when I understood that the last three children, including me, had not been baptized. It was the first time I confronted Christianity in my young mind. How could my sister, who was so active in the church, be refused a cross? Was she also rejected by God? I did not bring my questions up to my parents but the Presbyterian church and Christianity took a dent in my mind. When we returned to Buea after burying my sister, my mother became very sick. The impact of my sister's death had limited her to her bed. Our local pastor, Pastor Pefok, visited our house often to pray for my mom. My father would invite me and my younger sister to join him in prayer. Our older siblings were away in Boarding schools and university. We would kneel down with Papa by our

mother's bed as the pastor prayed. To see my father on his knees was life-changing for me. If he could still have such faith in that God, then that God had to be real. I quickly forgave the church for denying my sister a cross but I never forgot. Later that year, on Christmas day, my younger sister, Helen, and I were baptized. I waxed in my rebirth!

My father, an astute Presbyterian, also had a strong sense of his African identity, so he took us often to his village where we not only interacted with our extended relatives but also engaged in age-old cultural practices. I enjoyed traditional dances and traditional witty banter. I also savored our ethnic language and enjoyed practicing it with my relatives to whom it was the main language of communication. My father did not see anything wrong in talking with ancestors through the ritual of libation or asking elders to bless us with their spit during "ndoh." True, he was hesitant about groups like the Ekpe but that did not stop him from accepting an "honorary" *Seseku* title. Thus, I grew up with a Christianity that still allowed room for me to be African. All through my childhood and teenage years, my father remained an elder in the Presbyterian church and a lay preacher. My mother was active in CWF and sang in various choirs. My father's faith in particular was unshakable.

Then he died alongside my mother in a gruesome auto accident. Why? Why would God allow such a thing to happen to my parents after all their dedication to him? This section of my life is a book in its own right. My

Christian faith took a major hit. Ironically, that is when I developed a personal relationship with the Christian God. I started talking to him as I would talk to a human being. I expressed my annoyance directly to him. I often told him how I no longer trusted him. I even started the habit of warning him when I was afraid of impending trouble. For example, if I was going for surgery, I would tell him up front not to do anything funny. Laughter! I thought these conversations were unchristian but most of my more religious friends think it is a sign of pure faith.

I traveled abroad to Wales, UK in 1989. It was the first time I would live away from Cameroon for a period beyond six weeks. As such, I had to find a Church I would be attending. There was no Presbyterian church near me, but there were Anglican and Catholic churches nearby. I immediately decided that going to the Catholic church was out of the question. My reasons? Quite superficial: They believed in Mary and prayed with Rosaries and service was full of recitations. And what was wrong with that? I could not readily answer. Suddenly, I was struck with the question of why I was a Presbyterian in the first place. Again, I quickly realized that I had no answer to it beyond the superficial. Yes, I learned about the Reformation and John Calvin in primary school but I did not have that in mind in weekly Sunday worship. Forget that I was undertaking a Master's in Library Science so I could have embarked on research about it, but I was too busy with my studies to engage in theoretical religious issues; so I continued being a Presbyterian

even without the underlying theology. In Wales, I settled on the Anglican Church. It was the nearest thing to the Presbyterian church around me in terms of worship service. Then I discovered another thing, a big part of churchgoing was fellowship. Now fellowship was not the same away from home. I went to church but missed my family and friends. I wondered how many persons in Cameroon went to church driven by the need for fellowship, not faith.

Then I moved to the USA and my church hunting confronted my blackness. I became black in a way I was not in Cameroon and Wales. Most forms I filled out requested that I fill that box of blackness. In Cameroon, my race did not matter since we were all black. In Wales, I was so defined by my foreign status as an international student that my color difference was absorbed in that space. I accepted my foreign status knowing it was transient. I was there for two years and it was over.

As I settled in the USA, my first instinct was to go to a black church. The nearest black church was a Baptist church. The service was unusual. I found it extremely long and quite loud. I was also surprised to see paintings of Civil Rights leaders in the church. I did not realize how the church and that movement were intertwined. I finally found a Presbyterian church, which was predominantly white. Interestingly, I felt at home. The service was familiar and the songs too, but I quickly realized the familiarity did not come from the theology but the fact that the white church is the one that came to me

in Cameroon via colonialism. This discovery sobered me. I was torn! Shortly after that I also read a lot of feminist books in my doctoral program. I read Obioma Nnaemeka, Mari Matsuda, Meena Alexander, Michelle Cliff, among others. My gender awareness reached new heights. I started questioning God's gender as vigorously as I questioned "His" color.

I started asking myself the question, "If my parents did not choose my faith, what faith would I have chosen for myself?" In attempting to answer that question, I went church hopping and was open to other faiths. The process was exhausting, and I gave up. My oldest sibling, whom I had confided in, was only too happy to tell me, "I told you so."

I returned to the Presbyterian church but with a new framework, believing in the 10 commandments and the greatest commandment of all, "Love your neighbor as yourself." My church family became my family away from home, at least we shared common values. Again, so much to say here with incidents that happened in between. Some of my poems expose my mind. In one of my frustrations with my God, I wrote this one:

Prison Walls of Fruit

Dear God,
Just a few words
Before I leave your sight.

I felt ensnared
In your Garden of Eden

You gave me words
Then claimed my tongue

You gave me songs
Then kept my voice

You gave me eyes
Then took my sight

You opened your ears
But sealed my mouth

I learned to walk
But to nowhere

You gave me a man
Then kept his manhood

The one person who cared
You cursed him for good.

I don't regret leaving
These prison walls of fruit

Yours truly,
Eve

At another time when I was resigned to my faith, I wrote this for my two sons:

Mile 29*

Sons, I can't answer all your Jesus questions

Can't tell you why he's white in all your books But I'll tell you what my sons, I have made him my Mile 29.
That stop at the bend
A place to refill
A moment to rebuild

Between Joseph the Dreamer and Esther
I have learned a thing or two
I try to treat men and women fair
I try to love my neighbor as myself
I covet nobody's things
I honor my mother and father
And when it gets rough, my sons
I look up all the promises in the book,
I hide in Psalm 23
And own Psalm 100
So, my sons, I may not know
When Jesus will come

* Mile 29 was a stop between the towns of Ekona and Muyuka, in the Southwest Province of Cameroon where there was a natural spring. Travelers who plied that road frequently stopped there to generously satiate their thirst.

It may not matter whether he's black or white
Just make him your Mile 29
Stop there ev'ry now and then
Cupped hands in unison
Drink of his wisdom
And forget the rest.

(These two poems are published in *A Basket of Flaming Ashes*, my first collection of poetry)

Then entered COVID-19 and Black Lives Matter resurfaced with a vengeance. It was time to confront my God again. Luckily for me, the process started when Kobe Bryant suddenly died and my older son, 24 years old, started asking existentialist questions about life after death. After many rounds of discussion, he hit me with the question, "What did Africans believe in before colonization.?" "Is it ok that we are worshipping a Christ that is presented as white?" What he did not know is that I had confronted our pastor a few years prior with the same question and he directed me to read, *Knowing God* by JI Packard. So, long before the Black Lives Matter movement asked for the dismantling of the image of a White Jesus, I was privately engaged with it before my son brought it to the open at home.

His questions opened up for me the space to continue dismantling the hideous religious monuments that had tormented my Christian life. But once dismantled, what would I replace them with? Do our African Gods

still exist? Did they survive the onslaught in other lands because they vanished in my land Cameroon?

Yes, religious leaders should seize this reflective moment to review and rethink religious doctrines, but this is a precarious time as people are relying on hope. How do you dismantle long-held beliefs without dismantling hope? I faced that dilemma as I tried to give my son answers.

My dear Eric, I don't know whether I scratched the surface of your question, but it definitely loosened the tongue of my mind or to put it differently, you just launched a planting season in my thinking farm. Maybe I have just cleared the grass; there is burning to do before the soil is tilled for planting. In the meantime, I long to hear how you are re-evaluating this moment in our collective history as a Christian. Of course, I am assuming that you are a Christian. I guess you will tell me more.

Looking forward!
Joyce

Reply to Letter 1

July 6, 2020

My dear Joyce,

It's been two days since I received and read through your letter. Forty-eight hours spent ruminating on the vast range of issues you raised in an attempt to answer that simple existentialist question that COVID-19 and the ensuing lockdown compels us to confront: who are we and how do we relate to God and the universe? We agreed that the search for answers is something imperative if the lessons of this truly global pandemic are to be learned and used to serve mankind.

I am deeply grateful to you for opening up the canvas in ways that allow us to paint in broad strokes the many images that come to mind as we reflect on the central question. The whole COVID-19 experience is global in scale and touches on every aspect of life on our planet, from the circumstances of each birth to how we die; from believing in God to the place of religion in our lives; from the myth of Eden to the reality of the man who died on the cross some two thousand years ago, and how all of that continues to shape life on earth.

You started where all things seem to begin: God.

Your fascinating journey into the Jesus story provided something of an emotional roller-coaster that forced me to reflect on my journey. You captured some life-defining moments: of your sister drowning and of both your parents coming to the end of their lives together in a road accident; of coming face-to-face, as never before, with your "blackness" in an American church and being made to wonder what the real nature of the God you grew up worshiping is; of being forced to talk to God in a very personal and human way, and then having to engage with your son with his own questions around the same issue.

I could not help but think of what I came to call "my Road to Damascus," an experience that brought back to me the biblical narration of Saint Paul's conversion during his trip to that Syrian city. It was on a Sunday morning in Baltimore, Maryland, a couple of days after Christmas in December of 1981. I woke up early, not to accompany my girlfriend Mariam to church to please her grandparents in whose home we were, but to listen to my favorite radio program, "American Top 40" with Casey Kasem. I always listened to the program and copied the countdown from the last to the top song of the week. Mariam had left for church when the countdown started and I was prepared with a pen and my notebook to do what I did religiously every Sunday morning. Did one of the Reverend Brothers in my old school, Sacred Heart College in Mankon, Bamenda in Cameroon, not tell us one day that "God will bless you for doing what you have

to do with undivided focus, commitment and devotion"?

I heard and wrote down the first three songs of the countdown from Number 40 and, for some unexplained reason, did not hear the next five songs. Not understanding how I could have missed some songs when I heard Casey announce song number 32, I jumped out of bed with my pen and notebook. Again, I missed numbers 29 – 26, then 21 – 18 while constantly walking around the room and reminding myself that I was awake, numbers 15 – 12, 8 – 5, and the Top song of the week. Angry with myself, and unable to figure out what happened, I lay down in bed and went to sleep. Almost immediately, I seemed to hear the voices of two people, Reverend Brother Vincent, my secondary school principal, and a preacher, whose name I only got as Peter, when Mariam forced me to listen to his sermon on Christmas Eve. I knew I had not listened to Peter when he preached but his voice and message came to me with absolute clarity, as did that of Brother Vincent, who spoke to me about the Apostle Paul. When I recounted the story to Mariam after she returned from church and told her what Peter said, she was flabbergasted. "You must have been listening to him all the time even though you gave me the impression during that sermon that you were sleeping." I had not listened to Peter and had only feigned sleepiness to convince Mariam that we should go back home quickly. But here she was, convinced that I had just recounted everything she remembered Peter saying.

Of everything both Brother Vincent and Peter told

me that Sunday morning, what I clearly remembered was something about going back home to Cameroon, to be prepared for all that would happen to me, and to remember that God would be with me all along. At the time, I was not thinking about going back home and Mariam discounted the idea. Yet, I was on the plane to Cameroon within a few months after that weekend in Baltimore. I encountered unbelievable hurdles upon my return home but always had reason to remember the voices I heard that Sunday morning and their central message. They did not take me to church, but they brought me as close to God as was humanly possible. I remained disillusioned with the church but my spiritual growth started on that day and has been growing ever since. COVID-19 was a chance to take stock and to easily feel the absence of the voice of the religious community from so grand a human predicament. I said this in recent tweets: "Where are our so-called Men and Women of God when our common humanity is so challenged and yet glorified?" Or again: "…institutionalized religion must re-invent itself, address itself in ways that resonate. They're not doing so." Or yet again: "…where are the churches, mosques, and shrines when humanity is so challenged? Deafening silence!"

I ended up overcoming the hurdles that were thrown up at me when I returned to Cameroon in 1982 and, as if to prove the veracity of what I had come to believe was a spiritual encounter, I ended up having to take the lead in one of the projects that would change the country forever: Cameroon Television. From the day television

first went on air, on March 20, 1985, and I made its first "live" presentation to when I left the country six years later, my whole life was given to that project. Along the way, I encountered just about everyone who had thrown one of those hurdles, and each time I would bring them into my orbit and work to get the best out of them. In 1991, I was exhausted and needed to take a holiday for the first time in six years. I had just come out of a difficult fireside chat with the Head of State and had failed to convince him that with the switch from a single to a multi-party state – announced on June 30, 1990 – public television in Cameroon had to reflect the emerging multiplicity of voices in public opinion. Five times, I brought up the issue and five times the President would tell me that the matter would be dealt with sometime in the future. On the way back to my office from the Presidency, I was lost in thought and must have said a prayer about the need to finally take a break from work. My assistant rushed to me when she heard my office door open and said I had to call Kim Norgaard of CNN in Atlanta. I did, and Kim tried to convince me to come to Atlanta for a special program involving CNN World Report correspondents. I had not been able to attend the two-month program the year before. Kim did not know this but I was quite ready for it. I believed this was the holiday I'd been praying for and I left Cameroon a few weeks later with the absolute certainty that I would be back in a couple of months. Well, it's been thirty years since!

Here I am, Joyce, three decades since leaving my homeland, caught up in a lockdown of reflection over a global pandemic that may well change the way we see ourselves and each other, how we manage the affairs of the earth, and where we find God in ourselves and the universe. It appears that a singular act that woke the world up to the need for this happened in Minneapolis with the murder of George Floyd. You and I talked about this already. Is this going to be that important wake-up call, or is life after COVID-19 (AC) going to return to some kind of normalcy, and are we going back to our bad old ways of pollution, racism, poor governance, religious emptiness, war, and attrition?

As you recalled in your letter, we discussed the need for the voices of leaders in church, government, the private sector, the media and academia, and in global civil society, to speak up and help humanity articulate the values of the new world that must emerge from this pandemic. What world are we going to bequeath to the unborn generations for whom we hold the earth in trust? I am hopeful we will take this conversation to some logical end.

Did I answer your last question about whether or not I am a Christian? I suppose I went deeper than offering you a simple answer, right? My twin sister Irene and I were baptized and took the first holy communion in the Catholic Church at the age of eight, I believe. I went to Sacred Heart College, Mankon, a Catholic boarding school for boys and Irene to Our Lady of Lourdes, a

Catholic school for girls. Our mother died about six weeks after she and my dad dropped us off at our respective schools. Dad passed on some forty-seven years later, in 2012, after seeing us through school, college, and university. It took me three years in college to finally let go of my mother – she was in my thoughts virtually every day in class, in the dormitory, in the refectory, and on the playground where I had been when one of the Reverend Brothers came for me and announced her death by accident – she hit her head in a fall. The most mind-blowing experience of my spiritual journey would come about, thanks to my mother. Are you ready for this? We will continue to discuss the World After COVID-19 but I will recount that experience as one of the subjects of my next letter to you.

Godspeed,
Eric

Letter 2

July 21, 2020

My dear Eric,

Thanks for your reply. It is amazing how the petals of our lives unfold. I was a vibrant high school student when you burst on the scene in Cameroon with the launch of Cameroon Television. I have great memories of that time because our house in Bamenda was one of the few to have a television set. My sister, Dr. Martha Zama, had just relocated back to Cameroon from Nigeria and brought with her a good-sized TV, so when CTV went live during the CNU congress and the Pope's visit in Bamenda, we were right there as witnesses. Those were exciting times in Bamenda with the Agric show too. It was during that time that I made my debut as a young poet on national radio. To mark these events, the nationwide program, Luncheon Date, emanated from Bamenda with David Chuye Bunyui (DCB) as host. Even in those days, I had already made my mark as a young poet and performer and DCB invited me to read my poems on the air. He had heard about me from my literature teacher and Theater director, Tangyie Suh Nfor, who was his friend.

Well, how fascinating to go backstage to read what had transpired in your life shortly before your very public CTV/CRTV years, and your eventual departure just about the time I returned to Cameroon from the UK. Although you captured your departure from CRTV with just a few sentences, the exhaustion you recall has stayed with me. Your description of the day you left the Presidency to your office only to receive news of the call that eventually became your pathway out of Cameroon reads like a movie script. I could feel you carrying a collective weight that has remained palpable in your words three decades and more after the fact. That feeling pervades me now as I write. I pause; I heave a sigh as I shove my thoughts for another time.

Back to the topic that brought us to this place of letter-writing reflections on our religious faiths and other values in the face of COVID-19. Well, I cannot wait to hear your spiritual awakening after your mother's death and the details which frame that narrative. The impact of her sudden death is something I can relate to from my own experiences. Not surprised to know that her death brought about a reframing of your relationship with God or belief system, but let me not go ahead of myself here. I will wait for your telling. These thoughts must roll out in their own good time, teased out by forces beyond our bodies. What took me by surprise was the fact that you are a twin. I did not see that coming. That tells you my knowledge of you is limited to the public domain although your sister, Colette, and I share a very

close friend, Quinta.

Then your Baltimore conversion story! Fascinating that you were able to distill the message from Reverend Brother Vincent and Pastor Peter. It is interesting how the proverbial weight of the world kept distracting you from hearing the voices as you struggled to get the songs in "America Top 40." However, your faith prevailed. You were able to latch onto the promises they made that day which sustained you during your stay in Cameroon until you left. Nevertheless, the conversion did not transform you into a weekly church-going Christian, or so I gathered. I mentioned something similar in my last letter, how I developed an intimate relationship with God but that did not transform me into a weekly do-or-die church-going Christian either.

So why are spiritual leaders not using this COVID-19 season to engage with some salient religious truths? It just occurred to me that maybe they are doing so directly to their dedicated flock and we are missing out. I chuckled to myself as this thought crossed my mind. Then, I should only speak for myself since I am presently not a dedicated consumer of our online worship service. However, this cannot be wholly true since great spiritual leaders talk beyond the walls of their local churches. The news media often notice what the Pope has said or what the Dalai Lama has said. So far, I cannot recall whether I have encountered any insightful comments from them regarding the pandemic. I guess we will continue putting our ears to the ground to catch the magic words.

To complicate this COVID-19 period for Christians, the Black Lives Matter movement brought into question the promotion of the white image of Jesus by the West. That discussion with my children is still very much on our table. I am still finding ways of making sure my boys can still take what they can from the Bible to enrich their lives while neglecting the aspects that shackle them. My older son, who is starting law school this fall, has already learned how to pin me on the witness stand with those questions that expose my limited knowledge of any Afrocentric alternative to the white Jesus. At such moments, I realize how deeply colonialism robbed us of our identity.

What to do? I am taking out leaves from my father's parenting book. Papa dealt with a version of these questions. Interestingly, they came from his only son, our lone brother among five girls. As a teenager, my brother did not like going to church. He frequently expressed his frustration with a religion that would discount people doing good if they did not profess the Christian religion. He challenged my Dad by asking insightful questions. He often asked my father why someone like him would go to hell just because he was not going to church. What evil had he committed? That argument often got my father quiet because my brother was the calmest of his children and was not troublesome. At the time, the whole discussion of faith being above works (acts of kindness) was not as prevalent as it is today. Fortunately for our brother, Papa was a humble man and very democratic.

At such times, he would repeat what he often told us, "My children, I can only show you all what I know. My illiterate mother found something captivating about the Christian religion and joined the fold. She brought me along and I have brought you all with me as well. Do your best to conform to the faith. It will make you a more productive person. If you die and find out there's no God, at least you must have led an honorable life." That made sense to me and still does. I like the fact that Papa did not talk about religion in absolutes. He left room for doubt and growth. I have since learned that Papa's perspective is called "Pascal's wager" in theology. I don't think Papa was aware of this because being the teacher he was he would have told us about Blaise Pascal, the 17th century French philosopher who provided a pragmatic reason for believing in God even with the possibility that he does not exist. I hold on to Papa's reasoning and I have given it as a frame to my children through which they can "cope" with Christianity even though I know some theologians have taken Pascal to task. Being a parent in the USA has forced me to confront my Christianity in ways I never imagined.

Did you answer my question of whether you are a Christian? Yes, you did even as you triggered other questions. I guess we will continue holding ourselves to the same "values we expect from leaders of the church, in government and the private sector, in media and academia, and global civil society" since we belong to one or more of these categories in our immediate community.

I believe we must be able to "articulate the values of the new world that must emerge from this pandemic" for ourselves first.

I guess to get to that point, we will continue sifting through the debris of this chaotic time to find the values we must "bequeath to the unborn generations for whom we hold the earth in trust."

Yes, I hope that we will not only end this in a wholesome place but we can find truths that are barricaded in the fragile parts of our being. As Brian Doyle says, in his beautiful essay, "Joyas Voladoras," "…So much held in a heart in a lifetime. So much held in a heart in a day, an hour, a moment. We are utterly open with no one in the end—not mother and father, not wife or husband, not lover, not child, not friend. We open windows to each but we live alone in the house of the heart. Perhaps we must. Perhaps we could not bear to be so naked…"

Yet, the season of COVID-19 continues to disrobe and expose us. Moreover, long before COVID-19, we had to endure the crisis and mass deaths in the civil war that erupted in our backyard in Cameroon. Beyond the politics, how are you coping with that? I am dying to compare notes. Did you also hear of the murder-suicide in Ohio that rocked our Cameroon community in the USA? Ah! Until I hear from you, take care and stay safe…

Joyce

Reply to Letter 2

August 11, 2020

Dear Joyce,

It's been over two weeks since I received your July 21 letter, but I felt no pressure to respond to the issues you raised, not only because we have been on the phone a few times since but also because so much has been going on in the world around us. An enhanced form of online communication, currently dominated by the application Zoom but also including Microsoft Teams, Webex, Skype, and others, has emerged as a principal feature of what may constitute the new normal in human affairs. I have been taking part in a rising number of these online conferences and activities, and the virtual convention of the Ex-Saker Students Association (EXSSA-USA) that you hosted last weekend will stand out as one of the leading events to usher in the new post-COVID-19 age. How you pulled off that rich and diverse menu of weekend activities, including presentations, debate, music, and dance, will be studied and replicated by many, I believe.

The Zoom conferences I took part in since the start of August included two that deserve mention here: firstly, the Black Philanthropy Month (BPM) Global Summit

organized by the Indiana University Lilly Family School of Philanthropy and, secondly, a conference on changing the Africa narrative in the post-COVID-19 era organized by both the World Bank and the Johannesburg-based organization, Africa No Filter. The Summit opened my eyes and mind to the challenges and potential of the African philanthropy ecosystem and the second sought to re-focus efforts that will have to be made to re-position the continent in the emerging new age. I will be happy to discuss both subjects more lengthily over the phone, or in person.

You came back in your letter to the exciting first days of television in Cameroon. For the central role I played in that exercise, I believe I owe it to Cameroonians and all future students of that medium to write more extensively about all that happened in the lead-up to March 20, 1985 – the day we effectively launched Cameroon Television (CTV). The main challenges we had at the time included: how to effectively bring an electronic medium into a pre-industrialized society; how to introduce a country to its citizens who were largely ignorant of what lay beyond their immediate geography; how to integrate this dynamic, visual, and real-time medium with the monolithic and staid politics of the period. Television in Cameroon was a life-changing national event. There were also two global events happening outside our borders that hardly created a ripple locally but would significantly change the world as we knew it: Mikhail Gorbachev had just replaced Konstantin Chernenko as

Communist Party General Secretary in Moscow and, days later, the first internet domain name – Symbolism.com – was registered. TV would change Cameroon forever; Gorbachev would launch *Glasnost* and *Perestroika* – policies that would result in the fall of the Berlin Wall and the end of the Cold War, and "Symbolism.com" would initiate one of the greatest technological revolutions ever known to man. I only found out recently from a close Ukrainian friend, who was born and lived in the Soviet Union most of her life, that Mikhail Gorbachev was reviled by his countrymen for what he did to his country. I am currently investigating the veracity of that position but you will remember that he was awarded a Nobel Prize for his achievement – "by the West," my friend underscored.

I remember waking up on that Wednesday morning of March 20, 1985, and getting ready for what I suspected would be an important date in the history of the country. I was going to anchor the first newscast in English that evening and had carefully chosen the suit, shirt, and tie I would be wearing. I was conscious of the impact everything would have, including on the minds of French-speaking Cameroonians, who had always felt that their English-speaking kindred were much less sophisticated and constituted a lower class of citizens. I checked the mirror one last time to be sure that my colors matched well, every hair on my head was in place, and my tie was well knotted and positioned appropriately between the collars of my shirt. I then asked my

dad what he thought about my "look" and the fact that his 30-year-old son would be making history that day. He smiled broadly and said encouragingly, "God will see you through."

We had built a makeshift studio that would become the birthplace of television in Cameroon in an unfinished structure that eventually housed the regional office of the Ministry of Telecommunications in Bamenda town. I could not help but force a comparison between a more momentous but equally humble birth: Christ in a manger. That evening, the first newscast by my colleagues Dieudonne Pigui and Denise Epote would be delivered in French; it was pre-recorded. The first "live" newscast with me in the anchor seat was in English and came shortly after the news in French. Public opinion was unanimous the next day: the news in English won the hearts and minds of all who saw Cameroon Television's first news broadcast.

It's been a little over thirty-five years since then, and it is clear you have gone from a young, fledgling poet to a published and respected author and lecturer of poetry and literature in Cameroon, the United Kingdom, and the United States. I, too, beat a path out of Cameroon at the start of the 1990s, first to CNN in Atlanta, then to Harvard in Cambridge, and finally to the World Bank in Washington DC where I would spend the next two decades in development work. It seems to me that our professional and academic trajectories were equally accompanied by a spiritual journey that is still ongoing.

This brings me to your mention of our late parents and what I said about an encounter with my mother on August 12, 2018! The COVID-19 lockdown in the US has certainly provided us the luxury of time to reflect on some of the more important punctuation marks in our life narratives.

Well, I will briefly talk about that Sunday night in August when I got word from a clairvoyant in Houston, Texas, that my mother would be "manifesting" herself to me. We were in Fairfax, Virginia. The family had just had dinner and was engaged in the last conversations before bedtime when my visiting sister Collette's phone rang. I was watching TV as she responded and said, at some point: "Well, he is here; you can tell him yourself." I took the phone and was informed by Beryl – a family friend whose near-death experience a couple of decades earlier had left her with some ability to communicate with the beyond – that she had received word from my mother, who died over fifty years ago, that she would be coming to see me. Beryl had no answers to my many questions: When? Where? How? I shrugged, figuring this was one of those phantasmagoric pronouncements that folks with "a second eye" would often make to confound the rest of us. I had had reason to take Beryl seriously but this one, in my view, went beyond the confines of reason. I eventually went to bed well after everyone else and, as I leaned over to switch off the lights, I heard a knock on the door. I thought it was my younger son, Michael, and wondered why his knock would be coming from a

side of the room where.... I barely had time to think. "There is no door there!" I did open that "door" and saw my mother: "You are so young" I clearly remember saying, as she took me into the "room". All I can tell you now is that my life has never been quite the same since.

I am still growing spiritually and helped in that exercise, I believe, by my mother and those on the other side. I relate to them more sympathetically now. I am no Beryl, of course, and know nothing more than what I know in these mortal clothes. I am, however, able to process the COVID-19 pandemic, the BLM race riots, the crash of economies, and the seeming decline of the American empire from a perspective I do not think I would have had before that August 2018 rendezvous. When I told you about the relative silence of religious leaders on these issues, it was because I occasionally find myself in a space where I can almost feel the pulse of our human existence, its rhythmic consistency or dissonance. At this time in our lives, I cannot help feeling that the church ought to rise to the occasion; it has not! Am I expecting too much from the women and men of God who, I want to think, should be helping us comprehend that which lies between us and the vast continuum to eternity? There was one night a few weeks ago when I thought I had gone into that space – I dreamt, maybe – and there I felt the deafening silence of the Pope and other people I expected to hear from. I am writing this and almost hoping I will be thrust into that space one more time to find inspirational words to relate to

the experience. I have no power over that and it is not happening – not tonight!

The quest for understanding continues. The discussions you've been having with your boys and your reference to Pascal's Wager are very much at the heart of our human search for meaning and purpose. Very interesting how you put it: "My hope is that we will not only end this in a wholesome place but we can find truths that are barricaded in the fragile parts of our being." Has COVID-19 not shaken things up enough to force us all into a re-think of who we are, what we live for, and what lies beyond the mere fact of daily existence? Is this viral experience a simple blip in our history that, as President Trump says, will just disappear and return life to where it was before the pandemic?

Coronavirus, the silent and invisible messenger, delivered a harsh message about our relative impotence and the fragility of our human existence. It revealed the fault lines in our social edifice, here, there, and everywhere. It showed us what could lie on the other side of a sane approach to environmental matters. The confinement it spurned forced us to revisit our consumerist values and our belief in things material. It compelled us to question the power of science to find immediate answers to things that challenge us. It exposed the distortions in national societies. It virtually brought America to its knees and had the world scurrying to redefine what it means to be a venerated superpower. COVID-19 forced us to question our notion of development and what ought to

be its endgame. A lot of my African friends have called and expressed sympathy for our situation in the US; you may have experienced that too!

That is why we agreed to try and envisage a world on "The Day after COVID-19" – if ever there is such a day! The future is upon us already and we must take it on with a sense of possibility and promise. Will Africa re-think the trajectory of its development and work to achieve it? Will the legacy of slavery and colonialism – historical realities that came to define generations of Africans and their place in the emerging new world – finally be buried and the power of a new awakening propel us to where we know nature would have us be? COVID-19 seems to have brought us to a new existential threshold and understanding, and we must seize the moment. We grew up believing that knowledge, wealth, invention, and production – all that would guarantee the good life on planet Earth – could only be found in faraway lands, overseas. Through the prism of this invisible virus, we are being forced to re-evaluate our view of humanity and our place on this little planet.

My family and I are still, for the most part, in quarantine. It is still the order of things here in Virginia. The lockdown has brought some realizations to the fore. I have come to realize I can live without a car; I have not driven one in over a year now. I have not been to the dry cleaners in over six months because I have not needed to constantly change and clean clothes. I have not touched a dollar bill in over six months and have not

needed to. I have not entered a plane in over six months and have not had reason to. I have participated in more conferences than I care to count over the last six months and read more books during that time than I did in the last ten years. I regularly go out for walks and have not only re-discovered my neighborhood but have come to appreciate my environment as never before.

At the start of this pandemic, and as America was having a most difficult time dealing with it, the consensus within the international development community was that COVID-19 would devastate Africa. I am always trying to find out how things are on the continent and if the expected devastation is indeed going to happen. I had this conversation yesterday with my friend in Africa:

Me. How are you doing, Yannick? I hope you all are keeping safe.

Y. *We are; I hope YOU are safe. My concern is for you and the family: are you safe? The news from America is frightening. What happened in that country?*

Me. Well, you make a point. We have not managed things well enough here. But I am just as concerned about you. You guys have opened up everything – the bars, schools, nightclubs, etc. – and I am afraid what happened here will come to you in only a matter of time.

Y. *You all have been saying that for months now. You've been telling the world that streets in Africa will soon be littered with the corpses of victims of the coronavirus. We believe we have found a way here to mitigate the impact of the disease but you and your Big Pharma will have none of*

that. You are waiting for Armageddon. Our people are not dropping dead on our highways and byways; our hospitals are not choking with the sick; people wear masks but even that too has become no more than something of a social statement, not a means of stalling the virus. Hospitals are actually paying families to sign on the death certificates that declare that their dead were victims of the disease. It appears there is money in it for them. We're not suffering from Covid-19; our problem is Pochvid (poches vides – French for empty pockets).

Me. I hear you! If you stay confined, you will resolve both problems – Covid and Pochvid – because you will successfully avoid one and have no reason to experience the other.

We found out the inherent weaknesses in the US health and social systems. We were reminded of the Ebola crisis that had exposed these same weaknesses in some African countries. The affected countries, with some help from their friends, figured out in a few months what to do to contain the crisis. America will, hopefully, figure out what to do about the coronavirus – possibly with some help from its friends. In the US, Africa, and Europe, we are even more aware at this time that we need to focus on health and all that keeps us alive. We must build our health infrastructure, engage with our friends, and maximize local responses to the crises we face as nations. That has to be one of the supreme learnings of the COVID-19 crisis, and one of the major takeaways as we move into the post-COVID-19 age. Is there a certain spiritual message in all of this? Should we not

be discussing some fundamental changes to how we come together as human beings, nations, and potential members of a higher order of being?
What do you think?

All the best,
Eric

Letter 3

August 18-October 15, 2020

My dear Eric,

I trust you are well. I am tired, emotionally and physically. The burden of this pandemic season has a way of creeping in now and then. Last week, I was in lockdown trying to make sense of a project I am supposed to be completing this week, then there are preps for a semester that is supposed to be as unstable as the students we are expecting. It was tough enough to teach three classes effectively; now, we have to prepare for each class in three possible modes, face-to-face, hybrid, and 100% remote. I am known for my resilience, but these past weeks have been tough.

The paragraph above was last modified on August 18 as my laptop shows. This was a week after I received your letter. As I had told you, I planned to reply within the first two days to get it out of the way because I knew if I did not do that it would take me a while. Yes, the project, I mentioned above actually lasted till 12 a.m.

on the 9th of September. The tiredness I mentioned reached a breaking point by the 7th of September, but I dragged myself through the finish line like an African woman hanging on while in labor as the family struggles to take her to a clinic miles away. I delivered myself of the "child" on the 9th. I am emotionally exhausted, but mentally, I am relieved. Well, here I am crafting a reply three weeks + later. Thanks again for honoring my invitation to attend ExSSA USA's first virtual convention. Your presence validated our efforts. It was not by coincidence that "the father of Cameroon Tele broadcasting in English" was part of this major virtual broadcast in this COVID-era by an anglophone organization in the USA. Many commented positively on your participation. Yes, we have spoken a couple of times after the landmark event but writing it down concretizes it for posterity.

Honestly, just engaging in this letter-writing exchange is revealing in itself. We chose to write because we wanted to, and I have to keep reminding myself of a time when people wrote letters as the only means of long-distance communication. My mind also goes to all those who were not literate in Cameroon and had to rely on other people to write their letters for them and read the responses to them. My aunt, Mami Lydia, comes to mind. She was the owner of the main store in my village. A tall, beautiful Amazon and shrewd businesswoman. She got married as a young woman and when confronted with prolonged childlessness, she left for Nigeria. In Nigeria, she dated European men, finally got a child

with a Nigerian and later returned to Cameroon in her 40s. She first settled in Kumba and then moved back to the village when Ahidjo clamped down on unmarried women living in the cities. She had a carriage of a princess, which she was. She was also known to be stern and no-nonsense.

Her letters were often angry letters written to her suppliers in Kumba. She often berated them for not sending her goods on time or sending her damaged goods. I had done a rare thing that summer, by asking my Dad to spend a part of my summer vacation in the village with my aunt. It would be the first time I was going to the village alone, let alone spending days there without my parents. My father obliged. Once I got to the village, I readily joined my aunt in selling at the store. I was also there one afternoon when a young man came to help her write a letter to one of her suppliers in Kumba. She dictated the letter in Kenyang, our ethnic language and he was expected to translate her words into English. She spoke, a couple of sentences at a time and he wrote it down in English. At the end, he read what he had written. As far as I was concerned it fell flat. The tone of the letter did not capture her anxiety about not receiving her bag of onions that she had paid for, nor did it capture the anger she felt that the bag of garri she received the week before was not as full as the previous one. I was not surprised when my aunty lashed out, disappointed at the letter. Unfortunately, Man No Rest, the driver who had to pick up the letter to take to

Kumba had arrived. After that, I told my aunt that while I was there, I would be her letter writer. Fortunately for me, a week later I had my chance.

My aunt was pleasantly surprised that my Kenyang was good enough. I understood her clearly and also spoke effectively. It was a similar letter, with slight differences. This time she complained about receiving 2 loaves of Kumba bread when she had paid for four. She also complained about the crates of beer she had received. The "33" Export was less in quantity than Guinness when she had more Export drinkers than Guinness. When I read the letter back to her, she was impressed and declared me the best letter writer. What she did not know was that I was an actress, so in reading my letter I took on her persona and read it as if she was the one reading. I brought her to life. I screamed where she was angry; cajoled where I wanted the vendors to give her extra; pleaded where I needed to show that she had lost most of her "capital" from the last sales and made no profits. I also inserted a word of gratitude when, unbeknownst to her, I added that if they supplied everything according to her wishes, a big dish of fufu and bushmeat soup awaited them. She was grateful. How I wished I lived in the village so I could write her weekly letters for her. Ah, Eric! A pang of nostalgia laced with sadness hit me as these thoughts crossed my mind. My aunt, Mami Lydia, died on 10th September 2011. I was not in Cameroon to take one last look at her but this letter-writing experience has brought her back to me, and I relish in the memory.

So back to your letter. I think you owe Cameroonians, Africans, a book on your full experience being one of the pioneers of Cameroon Radio Television. There is just so much that readers would benefit from such an exercise. Then the spiritual experience with your mother. I think you have unfinished business about this occurrence. Maybe this was your transfiguration? Why are you waiting for some spiritual leader, or leaders, to fill a gap you see during this pandemic? Why someone else to fill that gap?

10/15/20

After about a month I am here to wrap this letter up. The struggle has been real.

What also struck me about your letter is that 50 years after your mother's death she continues to be relevant in a direct way in your life. You may not know this, but this has been one of the most precious gifts you have given me during this season of emotional drought. I observed the 34th anniversary of my mother's death on September 1 and my father on September 11. This year the memory was brutal on me. I suffered physical and emotional exhaustion. On some days I simply existed. Your narrative about your mother coming to you five decades after her death made me realize my experience of still missing my parents was not unusual. It was good to know. As if in answer to my mood, Chimamanda

wrote an insightful and naked piece about her grief over losing her father.

As you may have realized, I am a single parent, which means that I am the head of my household. In these times of excruciating uncertainty, my boys need to lean their bodies and souls on my stability, especially in this tense racial climate in the US. I am the soil where their roots take off. Here I was, losing ground, but had to hold it for them even as the world around me demanded that I wear the cloak of a "strong woman." You became a witness to my vulnerability as I faded from view. So much to say here and so much I am still keeping in the folds of a culture that tells us to hold it in. Fortunately, I have learned in times like that to streamline, so I disappeared into me ... and I stayed there only touching surfaces I recognized–music and work I must do.

Then your email came about needing a blurb. I could see you were mildly upset about my insistence on doing it right and time was not on my side. For most people, words are just words -- a means of communication. For some of us, it is the currency of our existence. I hold words close to my chest -- they are my aces! When I say something, I want to mean it. Sometimes it comes as a surprise that one, like me, who defies stereotypes, can be that "rigid." But this is the yin to my yang that blends into a malleable dough. Glad you know that about me now.

I will send this letter off, I don't want to keep it any longer, waiting for a time that may never come. So much

has happened in the US since we had a full conversation. I have come to believe that between the election and the pandemic, we are experiencing our own Godot moment ... but in our case, Godot will come even if we can't determine in what form. It's time to look ahead and plan. I don't know what that means, but I am willing to start peering into that crystal ball.

I thank you for your patience. I thank you for your understanding. I congratulate you on riding the storm of COVID-19 with your daughter. I read that in your text and had to hold myself not to reply, so my brain would not mistake that for the letter I must finish and send. The parent in me paused and whispered prayers I could have screamed aloud if I had heard at the time. Well, I can't wait to hear how that all played out and what reflections resulted from it, especially if she experienced mild to severe symptoms.

Looking forward to talking with you! It's been a while.

Joyce

Reply to Letter 3

March 2, 2021

Dear Joyce,

I am finally back in our common space, and it feels really good. I hope all is well. Heartfelt apologies for this delayed response to your last letter.

OMG! These COVID months roll by so quickly, so uneventfully, and days come and go as if time had become a non-entity, irrelevant. Yesterday merges readily into today, today into tomorrow (becoming yesterday in the process), and the notion of time – so much of it, I think – only seems to emphasize its nothingness. I sat down to respond to your last letter nearly two months ago and wonder now what happened in the intervening hours, days, weeks, and months? I can only hope now that I will send this to you before this day is over. [Shame on me; I did not!]

We have crossed a major timeline and entered a new year. There have been some remarkable things, heartwarming and heart-wrenching, that should rightly serve as signposts for us as 2020 regresses farther out in the rearview mirror. You reached the pinnacle of your craft and donned the full robe of Professor! What an

achievement! Heartfelt congratulations! You must give yourself the time to soak it all in and enjoy the full experience of getting to the top. How often do we have a chance in life to say, "I took those first steps up the ladder and I went all the way to the top?" You did, and you must take in that long breath and savor the fact! We will drink to that when I see you!

I told you I lost my best friend, confidant, cousin, and "twin sister" (we were born days apart from each other). You may have known her as Emerencia Nangah – she became Emille Nangah Alintah! She took her last breath on January 20, the day Joe Biden took over from the one person she had come to revile, Donald Trump. From her hospital bed in London, she always wanted to know what was going on during the US elections. "Any dirt on that narcissistic con artist is a super tonic for me," she would gleefully suggest. She died in Enugu, Nigeria, of cancer; another cousin passed away that same day of COVID-19 here in Washington DC. Emille's passage into eternity was no ordinary event for me as, hardly one hour after I was informed of her death, I truly felt what I can only describe as a movement of the spirit – a soft jolt that was over before I felt it or understood what had happened. We had a 12-hour long wake on Friday night and another 14 hours on Zoom to follow her burial in Nenwe (outside Enugu) in Nigeria on Saturday, February 20, 2021. I moderated both events and could not help thinking about what you did on Zoom a few months earlier to keep the Sakerettes virtual convention running.

I took another look at your last letter and some things caught my attention: first, the "vibes of September" which saw you in "labor" between the 7th and 9th – taking in my birthday on the 8th – and extending to Mama Lydia and your dad's passing on September 10 and 11th, respectively. Was it all a coincidence or part of the inimitable grand design in which we all exist?

The paragraph on Mama Lydia got me smiling as my mind flashed back to so much of what remained unsaid in your write-up. You pointed out that this princess of a lady "moved back to the village when Ahidjo clamped down on unmarried women living in the cities". (This is where I bring out the smiling emoji, reading that sentence.) Which one is it: a euphemism or a dignified play with language? President Ahidjo somehow thought he could do what no one before him had done in the history of humanity: bring an end to the world's oldest profession. I was in my early teens at the time and, thanks to a college big brother and 50 francs CFA from my pocket money, had my first exposure to the unfettered pleasures of my manhood! The order from the Presidency would pour a really cold shower on actors in a theater of activity that my friends and I were only too happy to be exposed to and be a part of. The edict from the nation's capital was ignored almost as quickly as it was broadcast on the radio and published by news organizations. I spent quite a few fifty francs at the time and often got a few bonuses for what was a fact of my youthful exuberance.

Man No Rest! Those three iconic words captured the essence of an era. A lot was happening in politics, the economy, and society in Africa in the fifties and sixties. Those years, I would later find out, came with moments pregnant with possibilities – my family bought its first automobile during this time; my parents both went abroad to university; I listened to my voice on a tape recorder for the first time – and the urgency of change filled the air. World War Two and its aftermath had resulted in an urgent need to reconfigure the world and Africa was not going to be left out. The period ushered in the independence years that resulted, within a short time, in the creation of some four dozen new nations on the African continent.

"Man No Rest" was no coinage by one of the political luminaries of the likes of Kwame Nkrumah who rose to lead Africa. No, it seems to have come from the simple mind of the entrepreneurial owner of that rickety hybrid of metal and wood – the lorries that plied our almost inexistent roads, connecting villages and towns, transporting goods and services between markets, providing mail delivery services, and beginning to give us the first sense of what a bustling economy could look like. Thank you for taking me back to an era that remained in the foggy lanes of memory but which "Man No Rest" brings back forcefully with a smile and warm feelings of nostalgia.

I will briefly touch on the second thing you brought forth from a more recent past: television in Cameroon.

This is my teaser for what I hope a more elaborate form will emerge in the coming months. Are you ready for this? This is what happened on the very first day of television broadcasting in the country: March 20, 1985! I presented the first "live" news broadcast that evening after the version in French that had been recorded. It was not supposed to have been that way. To avoid any potential embarrassment on this first momentous day, authorities had decided that everything that would go on the air would be pre-recorded. We had been working hard for months toward this rendezvous with history. The full program line-up for that first evening had been canned except, of course, for the news in French and English.

Reporters were sent out in the morning to cover events around the town of Bamenda where a 3-day Congress of the ruling (single) party was scheduled to take place. As they came back from the field, their reports were edited and lined up for the news. This process was slow for two reasons: a lack of equipment and experience. A couple of hours before the news, the French editorial and technical teams, led by the designated anchors, Dieudonne Tine Pigui and Denise Epote, began the recording. Mistakes occurred and each time the process had to be started all over again. By the time they got to an acceptable final version, it was too late to record the news in English. The administrative authorities in charge of the television project were all French-speaking Cameroonians and felt that this first newscast needed

to be done right… in French.

My team, the English-speaking reporters, decided to boycott the process and started walking out of the makeshift studio we were using. Their argument was clear: why should it be the Anglophones who would be exposed to the inherent dangers of a "live" broadcast on the historic first day of television broadcasting in Cameroon? The authorities had no answer to that and simply stood back and waited. I was the news anchor and it fell on me to convince my friends that we could pull it off if we put our hands and heads together. I told them the nation would understand if things went very wrong and we explained under what circumstances we had delivered that first newscast. I doubted if anyone would listen to us if there was no news in English that day. And what would history retain? Grudgingly, but with a sense of determination, they all came back and positioned themselves for the broadcast. I had started this day with a clear sense of history and reminded myself I was not going to let anything or anyone write that story in my place. I reviewed all preparations one last time, took the anchor seat, and counted down the seconds. "Good evening and welcome to this first live broadcast on Cameroon television," I said. The judgment the next day in the newspapers and by just about everyone who watched was unanimous: the news in English was the best thing on television that first night!

My dear Joyce, I will recount the full story of the early television experience in Cameroon in a different

and more appropriate context. Allow me to take you back to our original objective with some rather boring but necessary COVID-19-related reflections.

We are supposed to be looking at all that has transpired during this COVID-19 *annus horibilis* and looking ahead to a post-COVID-19 world, especially as it would play out in our neck of the woods in Africa. The world was in pandemic mode throughout 2020 but Africa seemed to be more on the sidelines than a central player in the theater of death. There was a lot of speculation as to why this was the case. As the death count mounted in Asia, Europe, and then the Americas, we started wondering if Africa had not become the place to be! It had generally been expected, especially by the international development community, that the pandemic would decimate the continent. Were there any health facilities in towns and cities across Africa to take in the expected flood of COVID patients? Where would needed ventilators come from? Could this be the time to finally question the mountains of debt that had been contracted over the years to build health systems? The development experts who were most responsible for the debt and guidance on health infrastructure were, once again, raising the prospect of more debt to "save Africa from COVID-19."

Most of the world was in lockdown when, at the end of May 2020, the government in Cameroon decided to lift the state of confinement that had been declared at the start of the pandemic. I did not believe it was the

right thing for the government to do but that got me (and some friends) thinking hard about lessons, if any, that we could draw from the whole experience. Was this an attempt of sorts by nature to communicate with us? What was nature telling us? We have spent long hours in Zoom conferences reflecting on this.

Health was, and for a long time remained, our primary area of focus. COVID-19 forced the world to take a hard look at global health systems and virtually every nation was found wanting. It did not require a medical specialist to know that public health in Cameroon – and many parts of Africa – was in an advanced state of agony. That, despite the billions of francs that had been pumped into the sector and the massive foreign debt that had accrued over the years for health infrastructure. We were not prepared for any shock demands on the system; not at a time when one of the big stories in the news coming from the nation's economic capital was of a pregnant woman who died giving birth at the entrance to one of the more renowned hospitals in the country. People in Cameroon, and in Africa, as a whole, did not think much of COVID-19 because citizens were dying of far less serious ailments. The pandemic was no more than a wake-up call, many people said. We must address the question as to why outcomes in health were no reflection of all the resources and ideas that had gone into developing the sector. A lot was clearly wrong with the approach, the governance, and the financing of health in the country.

Over the COVID-19 months, it seemed to me and those with whom I discussed these issues that food and nutrition had to be partially or wholly responsible for some of the hopeful outcomes we registered during the pandemic. Could it be that something in our nutrition was serving as a bulwark against the virus and other ailments? Had we paid enough attention to this or were we simply waiting for solutions that would come from our "friends" in the West? I have been collecting a lot of stories about the nutritional and health value of everything from fruits that grow in the wild in Cameroon to nuts and vegetables that are too commonplace to get any attention from policymakers. Should we not be rethinking our path to development in this and other sectors in the post-COVID age? It may be true that the South African variant of the virus will finally bring the full impact of the pandemic to the continent but this takes nothing away from the need to seriously begin looking inward for answers to some of our problems.

Our discussions have led us into the politics of existence in Africa and we have been revisiting everything from electoral politics – how can we nurture democracies without democrats? – and our export-driven economies which do not include regional cross-border activities or markets. We are caught in a torrent of policy contradictions out of which we must come if we are going to make sense of the way forward after COVID-19.

Apologies again, my dear, for the long pause before getting back to you. Please do not pay me back in my

own coins.

Cheers,
Eric

Letter 4

April 18, 2021

Dear Eric,

I am relieved that I can send you this reply. Well, what choice do I have not to accept your apology for your delay in replying to my last letter? There was no need to apologize. We are living in dystopian times and I think we just have to be glad we are alive. Yes, I waited for your reply and on December 10, 2020, I even enjoyed writing my fun follow-up email that mimicked the letters in those days written and read by English/Ethnic language translators who only had a rudimentary knowledge of the language. Truth is, time has conquered us in this COVID-19 era and you captured this in fascinating poetry:

> *OMG!*
> *These COVID-19 months roll by so quickly, so uneventfully and days come and go, as if time has become a non-entity, irrelevant.*
>
> *Yesterday merges readily into today, today into tomorrow becoming yesterday in the process, and*

> *the notion of time – so much of it, I think – only seems to emphasize its nothingness.*

And that is how you beautifully accounted for the delay in your last letter. I could not help but structure your prose lines into a four-line poetic stanza. You have a good draft for an engaging poem. And I completely agree with your perception of time during this period.

Can you believe I received your mail on March 2, and I sent you an email promising that my reply would not repay you in your coins? Unfortunately, I failed woefully, not because I intended to reciprocate but time just beat me to it. I do have a few reasons to account for my delay. Firstly, this semester I carried a heavy teaching load, another mark of this beast, COVID-19. With many adjunct instructors being laid off, or having reduced hours, we had to pick up an extra course. Truth is, I was given the option to teach the additional course during either the winter or summer sessions, but this African woman declined. I use summer teaching to earn an extra income, not merely to fulfill my course load. Lol. Consequently, I had to teach a four-course load this semester for the first time in my career. Normally, I teach three courses per semester, either on a Monday/Wednesday/Friday schedule or Tuesday/Thursday schedule. This meant having an extra day between classes. However, teaching four courses this semester meant teaching every day from Monday to Thursday, leaving me quite drained by Friday. I suddenly realized just how important that

one day between classes was. Then, as if that was not enough, I quietly initiated a project on February 16 to organize a dramatic reading of Bole Butake's play, *The Survivors,* by the pioneer cast, 32 years after the first performance at the Amphi 700, University of Yaoundé. Little did I realize that it would evolve into a major project. Fortunately, you were there to witness the results live on World Theater Day, March 27. The accolades of that trailblazing performance continue to find their way into my mailbox.

Immediately after that, I had to shift my focus to a celebration of my book award. I am not sure if you heard that my poetry collection, *Beautiful Fire,* won the 2020 African Literature Association Book Award for Creative Writing. My publisher felt the award deserved a proper celebration, which I am glad I accepted. I don't think you made it to this event, but here is the link. You can watch it at your leisure here: https://youtu.be/abogGs8UCZI.

As a result, following these two major events, the body begged me for a break. However, on April 5, in my capacity as Chair of ExSSA USA's Dreamers Scholarship Fund, I launched the pioneer edition of ExSSA USA's Dreamers scholarship. Within five days, we received a staggering 78 applications, prompting my committee to immediately spring into action. You may be wondering what the Dreamers scholarship is. Well, our previous scholarships in Saker Baptist College covered tuition for qualified students who are already attending Saker Baptist College. However, this one is different. As the

application form outlines,

> This is a new scholarship program for academically qualified female students in primary school in Cameroon, *facing extreme and prolonged unusual financial challenges*, who would otherwise not be able to afford a secondary school education, let alone a quality education program in a boarding secondary school like Saker Baptist College. This is a limited opportunity that is available to only three students this year but one that we hope to expand, with additional support from our community, in the coming years. While the underlying eligibility for this scholarship is extreme and prolonged unusual financial challenges, each year we may decide to focus on a specifically disenfranchised group. This year, our target group is 'Internally Displaced Persons' (IDPS). The successful students will be awarded full scholarships for seven years at Saker Baptist College, from Form One to Upper Sixth Form. This scholarship also ensures that the successful students are catered for holistically to ensure continued success in the classroom.

As you may recall, during the Namibian war of liberation, Cameroon was one of the nations that generously offered to host refugees from Namibia. Consequently, Saker Baptist College had the privilege of welcoming many Namibian students. Recently, the Class of 1984 had their 40th reunion in Namibia, graciously hosted

by their Namibian classmate. As you can see, we do have a soft spot for young girls displaced by war. We hope to model the care of the selected students on the compassionate support extended to the Namibian students. We aim to make sure that they have host parents who visit them, bring food during visitors' Saturday, and offer ongoing support. We envision this scholarship as a game-changer. We are also planning on a summer bridge program to prepare them for this life-changing experience awaiting them at Saker Baptist College.

The scholarship deadline is April 30, and so my team and I have been reviewing applications nonstop. Amidst this hectic schedule, I found a moment to respond to your letter, as I couldn't postpone it any longer.

Thank you sincerely for the warm congratulations on my attainment of full professorship. I promise to heed your advice to "take time and soak it all in." As you can imagine, I haven't had the chance to do so yet. However, I'm feeling pretty good knowing that I reached the pinnacle of my profession. I eagerly look forward to sharing a celebratory drink with you soon.

Now to your mega loss! Once again, you had a spiritual encounter. Well, I have often said that humans are spiritual beings but "the world is too much with us." Please, accept my profound condolences for the loss of your cousin-sister-friend, Emerencia, also known as Emille Nanga Alinta. Although I did not know her in this life, death introduced her to me through you. I could feel your profound sense of loss from your words

and your total dedication to her through your generous participation in her homegoing ceremonies. I can understand why your Zoom marathon for two days reminded you of the EXSSA USA trailblazing virtual convention. Looking back on it, I nod like the proverbial lizard that jumped down from an iroko tree. We created a path where there was none. As the sadness over your loss enveloped me, one comforting thought emerged to clear the sadness. I was glad that Sis Emille returned to her ancestors knowing the Orange one had been defeated. As for the multiple deaths, "What to do?" The prevalence of multiple deaths has become all too commonplace.

How do we even grieve in the time of COVID-19? That in itself is a topic for exploration.

Ah!

Regarding your interesting comments following my mention of Ahidjo's law for unmarried women, I want to clarify that it was no euphemism. Mami Lydia, who was an aunt and an entrepreneur I deeply respected and admired, was affected by that law. I understand how this may have brought back memories of that category of unmarried women who gave you that "first exposure to the unfettered pleasures of … manhood!" In one of Chimamanda Ngozi Adichie's celebrated TEDTalks, she cautions about the danger of a single story. For many of the women you encountered, your pleasure was intertwined with their pain. They sacrificed their dignity to give life beyond themselves. As their daughter, niece, sister, and extended relative, allow me to share with you

a story from the other side of that 50 francs:

Mary Eben-Asu was 13 when her father forced her into a marriage to get money to marry a wife for her older brother. Her husband-to-be was about 30 years older. He had two other wives who were much older than Mary. Mary tried to run away twice, but her family brought her back kicking and screaming. They had no bride price to repay for her freedom. With nowhere to run to, she accepted her fate. She had her first child at 14, a boy. By age 20, she had had three children, a boy, and two girls. She was pregnant with her 4th child when her husband died. Following customary practices at the time, the young Mary became the wife of her husband's first son by his first wife.

The two older wives were given to their brothers-in-law. Mary's stepson already had a wife but did not hesitate to claim Mary. Consequently, she became a wife to her stepson, a situation she hated mainly because they never got along in the first place. The stepson was only too happy to use his new position as husband to dominate and control her. His mother also saw it as an opportunity to humiliate Mary further. She encouraged him to impose draconian rules on Mary and treat her like a sex slave. Life became exceedingly difficult for her as she had four children to feed. She was illiterate and, as a girl child, had no inheritance from her own family. In fact, her family did not have much to live on either. She could also not run to her family because it would mean returning the bride price, which they did not have.

Her father did not even have a farm of his own. He was a sharecropper and Mary was tired of embarrassing her family.

The two farms her husband had allowed her to cultivate were slashed to a mere quarter of their original size. She watched helplessly as her children's weight declined, and she became a bag of bones as she toiled tirelessly from the farm to house chores. Unfortunately, her children were still too young to give her any meaningful assistance. In the past, her late husband used to pay some men to clear her farm to appease his young wife. However, those services were no longer available. Yet, her stepson frequently subjected her to physical abuse, convinced that she intentionally avoided getting pregnant for him. Adding to her woes, he threatened to withdraw her son from the local primary school, a concession he had grudgingly granted. Even though her son was already ten years old, he was still in Class 2, having joined the school at the age of 9.

During Christmas, Ma Emi, a local woman, who had been branded a witch and forced out of her marriage because she could not produce children, made a surprising return to the village. Contrary to expectations, she appeared healthy and vibrant. She was now living in Lagos, Nigeria, and had sent money back to her family to reimburse the bride price paid to her family. Some said she looked younger because she had lost no blood from childbirth, while others believed it was a result of a good life in Nigeria. Remarkably, she looked

more healthy than other childless women in the village. Ma Emi defied societal norms by sitting at the bar and sharing drinks with the men. She bought bags of rice and frozen fish dubbed "Morocco" for Christmas for numerous families in the village during the festive season. She was also paying school fees for her younger sister's children at the local primary school. Two of the children had passed the common entrance and were now in secondary school in Kumba.

Stories in the village do not hide. Before long, Ma Emi heard all that had transpired with Mary. Two weeks later, before the break of dawn, Mary left the village and became her companion. Mary confided in her older son, who was ten years old, that she would strive to make life better for them, and would come back much like Emilia. He was to look out for his three siblings. Tenderly rubbing his head, she handed him 500 francs, a sum she had diligently saved over two years, instructing him to hide it so no one would find it. She hid her tears as she painted a rosy picture for the young boy.

Mary traveled with Ma Emi to Nigeria. Ma Emi lived in a lovely house because she was the mistress of a celebrated businessman. She had graduated from a petty sex retailer to someone's mistress. She now enjoyed the comforts of life, and she used this privileged position to help her sisters, who had risked it all to travel to Lagos to begin the daring journey of reclaiming their self-worth and independence.

Ma Emilia usually took care of them for two weeks.

During this time, they regained their health by eating three square meals daily. That is what she did with Mary. On Mary's first night into this unfamiliar world, Ma Emi sat her down to explain:

"Mary, this job you are about to do is difficult. Don't forget who you are. Don't forget why you are here. You will allow both washed and unwashed men to come inside you, but always remember that you're doing this for the children you have left behind and yourself. There will be times when you feel like shit, and times you must swallow vomit. If you don't, you will return to the village just as you came and see your children in worse shape than you left them, and your parents will die before your eyes."

Mary listened and was not sure how this would play out. She had heard stories but now she was seeing it for herself. Within a week, news came from the village that her stepson-husband was harassing her family to return her bride price because she had run away. She heard of how her children were being ridiculed and mocked before they could eat crumbs and how they frequently went hungry. Her son had been forcibly removed from school. Driven by desperation and a mother's love, Mary did not need to think twice as she surrendered herself to one man after another. She did not look at their faces. She had been coached to replace those faces with images of her children. In a desperate bid for her children's well-being, Mary sacrificed her own body. Before long, she was able to send money to refund her bride price.

She also tried for her family to get her children, but their efforts were rejected.

Despite the challenges she faced during her initial two years in Nigeria, Mary managed to upgrade her father's house, replacing the thatch roof with zinc. When her father suffered a hernia, she could afford to pay for his surgery at Manyemen Hospital. Her newfound financial independence gave her some power. She reclaimed her children. The other wives were only too happy to let them go because caring for four kids in addition to theirs was an arduous task. She brought wax wrappers to repay them for their relative kindness while she was away. While they appreciated her kindness, they could not help but envy her. If only they were younger, they could also have left to try their luck in Nigeria.

Had it not been for the kids, Mary could have settled permanently in Nigeria. She was young and pretty. Many men even proposed to marry her, but she feared that marrying in Nigeria might make her neglect her children in Cameroon. She even had to end a very loving and lucrative relationship with a white man who wanted to take her to Germany. Despite the perpetual shame and loss of dignity, she persevered, scraping enough money to enroll her children in school while they stayed with her parents. She found the financial strain of caring for herself and supporting her family quite challenging. She was now living in a one-room apartment. She suffered from gastric pains which one doctor attributed to her deep yearning for her children. As if her struggles were

not enough, her mother fell very ill, and she gathered the little money she had saved and traveled back to Cameroon.

Her mother did not die but became too weak to care for herself and her grandchildren. Mary decided not to go back to Nigeria. She moved to Fence in Fiango, Kumba, seeking a new start. Similar to the support she received from Ma Emi in Nigeria, a woman in Fence helped her settle in. She later brought her children to live with her in a modest one-room shack. She wanted her children to receive quality education. She had seen that education could liberate her children and free them from the misery she was going through.

With no skills and no property she could call her own, she was ready to use her body again to earn a living. She planned to make enough money to buy farms after which, she would stop selling her body. In the meantime, she used some of the money she made to prepare and sell cooked food to market women during the day, but that was not enough. The financial struggle persisted, and she had to sell her body too to make ends meet.

And so, she sacrificed! Sometimes, it was 1000 francs from a government clerk after a long session of sex, or 300 francs from a low-level worker; sometimes, it was some young schoolboys who had only 50 francs. But every penny counted. For young schoolboys, Mary was ashamed because she thought of her son. In addition, the young boys made jokes, but she had no choice. She pretended to join the fun and jokes. Sex was no fun.

It was a thing of shame. But she often banished those thoughts as she tried to calculate how much she had made for the week and whether it would be enough for food, rent, and school fees.

Decades have gone by, and her son, the first seed of her womb, is now a Judge of the Cameroon court. He went to PSS Kumba with the help of a scholarship, then to CCAS Kumba, and on to the University of Yaoundé, and then the School of Administration and Magistracy (ENAM). Her youngest son, who was in her womb when her husband died, graduated from the Government Teacher Training College, commonly known in French as Ecole Normale Supérieure (ENS), located in Bambili, and is now a teacher. Her second child, a daughter, is a lab technician in Douala, and her younger daughter, now an IT Database Manager, is married to a Medical doctor who lives in New Jersey. This younger daughter is my friend. That is how Mary, now known as Ma Mary, spent two weeks with me in New York City, telling me the story of her life. There you go!

When I hear stories of young boys, like you who "spent quite a few fifty francs at the time and often got a few bonuses for what was a fact of ...youthful exuberance," I have to balance that with the stories from the other side of the 50 francs. Stories, like Ma Mary's, continue to haunt me because I know that there is a single story of this encounter that is prevalent in Cameroon.

Nawal El Sadawi gives voice to one of these kinds of women in her novel *Woman at Point Zero*. In this

novel, the main character, Firdaus, says this: "Yet, not for a single moment did I have any doubts about my integrity and honor as a woman. I knew that my profession had been invented by men and that men were in control of both our worlds, the one on earth, and the one in heaven. *That men force women to sell their bodies at a price, and that the lowest-paid body is that of a wife. All women are prostitutes of one kind or another.*"
- Nawal El Saadawi, Woman at Point Zero

Nawal El Sadawi died recently on March 21, 2021. I paused and took note. I was grateful for what she had bequeathed the world.

Talking about "Man No Rest," I was not surprised when you sent me the picture of that first Mammy wagon that went viral on social media. I know as soon as you saw it you remembered our conversations. Interestingly, the photo elicited a potent memory from my brother. He recalled that: "Man No Rest had two passenger lorries with the one captured in the photo being the first of the two. Following this, came the more famous version of the lorries. It had a longer frame and a neater finish. The sides of the lorry still bore the inscription "Brothers Transport Service." Somewhere lower was written, "Man no be God." Then, crowns were drawn towards the tail end on both sides. When this longer version of the lorry came, the driver of the original lorry, whom we were told was the lorry owner, took over to the new lorry and

began wearing an all-green outfit, with a white towel draped around his neck. Additionally, the driver acquired a camera for commercial purposes, thus becoming an itinerant commercial photographer. Along the Kumba-Mamfe road, he would stop and capture photos of the residents. His customers in the villages simply flagged him down and solicited his photographic services.

In fact, in his day, the "Man No Rest" driver was the main photographer along the Kumba-Mamfe road. He also possessed a hunting gun. Alongside his stops to take photographs in a village, he would equally stop to shoot monkeys and exotic birds like the hornbills. It is worth noting that with the introduction of the longer bus, the older bus was not discarded. Instead, it continued to ply the Kumba-Mamfe road. Its emblematic driver, however, moved to the new bus, while a new driver was recruited for the original bus. Consequently, there were two "Man No Rest" lorries in later years - the longer version and the shorter (original) one, featured in the photograph" (Barrister Tanjong Ashuntantang).

Another intriguing detail about "Man No Rest" was that he had the supernatural power to take pictures of deceased individuals without the corpse interfering. Consequently, when he made stops and encountered a corpse lying in state, the family was only too happy to get him to take the pictures. In those days, dead bodies were often a source of fear, especially with the cotton placed in the nostrils. There's so much of our collective stories that we need to document.

Well, well! I finally got my wish to hear you share a snippet of the early days of television in Cameroon. Once again, our marginalization as anglophones played out, but we triumphed in style. Talking about this marginalization and all the horror stories that have not subsided from our region, I am forced to ask for the umpteenth time, "How long, Lord!" Anyway, I hope after narrating that excerpt, you are now encouraged to tell the full story.

As for the COVID-19, which jumpstarted our letter writing, there is still much that requires clarification. While Cameroon, like most of Africa, seemed to have been spared the scourge of the first major wave, the second wave seems to be taking its toll. As you mentioned, the resilience exhibited during the first phase opened a door to our nutrition and also traditional healing practices. Unfortunately, conspiracy theories about vaccines, ironically unleashed from America, are widespread in Cameroon. To make matters worse, a considerable number of doctors in Cameroon are at the forefront of these theories. I also understand that some of them are still touting hydroxychloroquine as treatment, which has been a major cause of recent COVID-19-related deaths. Other doctors say there is confusion about the treatment with about ten (10) drugs in the list, and any one of them could cause a problem.

I maintain faith in vaccines. I just took my second dose and I wait impatiently for two weeks so I can be "free." Have you taken your vaccine?

We are getting close and I can smell a semblance of

normalcy, but the world is still clouded by the fog of the virus. Hopefully, we can soon sing like Johnny Nash, I can see clearly now the rain (insert virus) is gone!
Regards,

Joyce

Reply to Letter 4

June 14, 2021

Dear Joyce,

I am finally sitting down to draft a response to your Letter Four. The fact of not responding to you over these past weeks weighed heavily on me. I think I undertook more than I could handle during what felt like a limitless stretch of time. I am writing now in the wee hours of Monday, June 14. I had to impose this self-discipline on myself as I prepare to get into another intense week of action.

The first thing I did as I sat in front of my computer was go through your very rich Letter 4 for the third or fourth time. I initially went through it upon receiving it; read it again when I needed to get into the mood for a response, which I never got to; gave it a third reading when a compelling urge arose to revisit the story of Ma Mary; and, just moments ago, I immersed myself in it for the fourth time. I relate to that letter now at many levels and would gladly discuss them when we meet.

I must express heartfelt congratulations on your rise to the pinnacle of your trade, a topic we have talked about already. The Book Award for *Beautiful Fire* from

the Africa Literature Association; the captivating March 27 dramatic reading by members of the original cast of the play *The Survivors* by my former Yaounde University lecturer, Bole Butake; the scholarship initiative for the internally displaced persons (IDPs) in Cameroon; and the profoundly enlightening and heart-wrenching story of the girl-child who transformed into Ma Mary.

What you said about Ma Mary in reaction to my narrative on the exuberance of youth in my teenage years got me thinking about what message I would transmit, from my current perspective, to my fifteen-year-old self. Two words come to mind: Restraint (in taking on new or challenging experiences) and Decency (in dealing with the world beyond the self). I will tell my teenage self that an important lesson in life is to demonstrate restraint even in the most demanding of circumstances and when taking on new experiences. I will underscore the importance of decency as a cardinal principle of life and the need to project that in all situations. I believe that the teenager who is engrained with those values – decency and a sense of restraint, when both are called for – will grow up to be the man any society deserves to have!

And to think that that was not all that was contained in that letter. Thank you so much for it. Also, please convey my thanks to your brother for one of the many anecdotes he likely has about the events on the Kumba-Mamfe road in the hectic heydays when "Man No Rest" was a dominant feature. I assume more of the

stories still have to be told, am I right?

A new year came some six months ago, and we hoped it would quickly relegate that *annus horribilis* – 2020 behind us, ushering in an *annus mirabilis* with a new leader in the White House and a vaccine to conquer the pandemic. Now, at this midway point, I'm curious about your reading of 2021. Are we in the age of recovery? Do you see things as I do, that life in America – with the discovery of the country's underbelly that the Trumpian agenda has so effectively exposed – is increasingly burdensome, bereft of the magic of yesteryear? The initial ease of welcoming the Biden team on January 20 and the joy of receiving two COVID-19 vaccinations – I received the Pfizer version – has been significantly dampened by the persistence of social divisiveness and the politics of exclusion that are becoming a hallmark of the democracy in which we live.

In over three decades in America, I have never felt the urge to head back to a place and time I knew in Africa as strongly as I do now. However, I am compelled to consider whether the visible ongoings and outcomes in the USA might not quickly spill over and reinforce arguments in favor of autocracy in our part of the planet! Where can one take cover under the stars?

I look back to the pandemic months of 2020 and 2021 and feel obliged to reflect on some key takeaways:

Health, diet, and the organic wealth in our African cuisine. Have you not wondered at some point why the coronavirus continues to struggle to penetrate and

devastate Africa as some had expected, and even hoped for? Was ever the nutritive value of our herbs and condiments more in demand and appreciated as now— jangsa, ginger, pepper, garlic and okong-obong, njama-njama, eru, bitterleaf, etc.? I am increasingly leaning towards naturopathy to address the occasional medical challenges I have to deal with.

Technology and its transformative impact on life as we know it. The simple fact of being able to participate in a range of conferences and similar events from the relative comfort of home has thrust upon us all, I suppose, a willingness to commune with people everywhere and at any time. No hopping in and out of airports, hotel stays, and conference rooms. Platforms such as Zoom, Webex, Microsoft Teams, and other webinar tools have radically changed the way we work with the rest of the world, haven't they?

The fragility of democracy and what it will take to protect it. Did we not see how things played out here in America in the lead-up to and aftermath of the November 2020 elections? For the first time in my life, I was left contemplating the possibility of autocratic governance and grappling with all the challenges of a failed state in America. COVID exposed not only the weaknesses in the health sector but also the inherent flaws of a system rooted in exclusion and discrimination.

The fickleness of life and the need to question one's purpose on this side of heaven! One thing that struck me profoundly was the importance of renewing and

maintaining friendships. There were weeks when I was scared to answer phone calls because the announcement of the passing of a friend or family member had become such a constant. Did you go through that too?

Given the current state of affairs, I have taken a renewed interest in everything that is happening in Cameroon and conclude that I must collaborate with folks back home to reflect on the future of our country after the incumbent's mandate. We cannot afford to let our people wallow in fields of blood and destruction that the former Southern Cameroons is becoming, can we? In this regard, I intend to release an open letter, inviting all those living in that region, or those who hold it dear to heart to come together in a spirit of reflection on the path forward after President Biya leaves office in just over three years. Would you be interested in reviewing the letter before it goes out? I will be creating some platforms for the exchange of ideas, ensuring that the thoughts expressed are communicated in ways that inform our social discourse in the country in the coming years.

I am also drafting an outline on how to restore peace to English-speaking Cameroon based on a conversation I had with the late Cardinal Tumi. On the eve of what was dubbed the "Major National Dialogue," he and I drove from Douala to Yaounde, discussing the imperative for a return to a federation. This system, we concluded, would effectively enable citizens to have unfettered access to government, and the ability to determine who manages the commonwealth. Again, my objective here is to

enrich current conversations on what has been called the "Anglophone Crisis."

In my search for purpose, I have gone beyond the borders of the motherland, bringing together a group of distinguished communications professionals to think through what we, as a collective, can give back to Africa. You can go on the web and search for Kory Africa, SA (http://koryafrica.com) to gain an insight into what I am talking about. This, too, is an outcome of the months spent at home during the COVID-19 lockdown. I reflected on all the work I have tried to do in my field of activity to enhance the quality of life in Cameroon and Africa. I have tried to answer the question: why did God choose for me to be born in that part of the world, as opposed to others, and yet spend the better part of my life away from home in the United States of America?

I arrived in the US in the late seventies to pursue my studies, attracted by the abundance of higher education institutions and the quality of their academic offerings. Interestingly, during my time in the US, I, like many others, was granted the opportunity to become an American citizen. My American "parents" and I were overjoyed at the prospect of me becoming a citizen – an opportunity offered by the Reagan administration as a means of effectively addressing what it saw as an untenable immigration crisis. I was one of many who met the minimum criterion of having been in good standing in the country for over two years, and I promptly submitted my application!

It turned out that my passport was near expiration when I arrived at the Immigration office. I was informed that I needed to renew it before proceeding. I immediately went to the Cameroonian embassy in Washington DC to find out what was required and how long it would take to obtain the new passport. In 1981, things still worked in Cameroon and the embassy could deliver such documents within days. Both the Ambassador and the Cultural Attaché, whom I was acquainted with – assured me that the new passport would be expedited as soon as I provided the required documentation. The Cultural Attaché invited me to his office and told me how sorry he was to see that I was planning to renounce my Cameroonian citizenship in favor of the American. I told him I had no such intention. When faced with a choice, I made mine and have since remained a citizen of the country of my birth. Yet, I hope that a serious government in Yaounde will one day recognize the value of dual citizenship and enshrine it in the law of the land.

The luxury of time provided by the COVID months also allowed me, in my ongoing search for purpose, to reflect on my African experience and on what I could bring to discussions on the future of the continent. As you may be aware, a significant portion of my work over the past three decades, heading Communications at the World Bank, the African Development Bank, the Mo Ibrahim Foundation, and the African Media Initiative (AMI), has been on Africa. There has been much to think about! I went back to one of the many things that

exposed me to the vile hypocrisy of the international system and our place in it.

It took place during my years at the World Bank in the mid-1990s. I encountered a campaign gaining momentum to dissolve the Bretton Woods institutions, the World Bank Group, and the IMF dubbed "50 Years is Enough." A centrist president in the White House, Bill Clinton, was grappling with an isolationist agenda imposed by a conservative Congress led by Newt Gingrich that was eager to defund global public institutions such as the United Nations and related organizations. At the Bank, we had to devise arguments to justify continued American engagement with the institution. I was on the committee charged with this responsibility and I learned a great deal about this development institution in which I worked and believed in as an instrument for good. I discovered, for example, that the US received for every dollar invested well close to ten dollars from the Bank. This led me to ponder a crucial question: what does Africa receive in return for its "investment" in the institution?

The shocking response to that question, I was told, stemmed from the fact that African entrepreneurs were essentially absent from the competition for World Bank contracts. "*Why*?" I asked. The response was that no Africans are registered as vendors and are therefore not eligible to tender bids for contracts. I was then serving as the Vice Chair of the World Bank/IMF Africa Club and I proposed the idea of hosting an "Africa Business

Forum" in Washington DC in September 1998 to educate our businesswomen and men about lucrative opportunities in the Bank. I also sought to involve African-American entrepreneurs. Unexpectedly, a group of colleagues dismissed the forum's chances of success and actively worked for its failure. The head of the Private Sector Department in the African region said that "*No African businessperson will come to the US for the event if the Bank did not pay for the trip.*" He told me this just before opening the forum in an auditorium full of African businesswomen and men who had come for the event from across the continent. In his opening speech, the President of the Bank, Jim Wofensohn, declared, "*This is the first time in its history that the Bank is welcoming Africans who have not come with outstretched hands begging for assistance.*" It would turn out that most of the staff of the Bank Group, who had been invited to explain its operations to the guests from Africa, decided, rather surreptitiously, to boycott the event. They appeared when the President and senior management were present but left shortly after their departure. I concluded, at the end of that week, that the Bretton Woods institutions would never play a significant role in Africa's development, and that the continent would ultimately need to depend on itself to improve the quality of life for its citizens. I maintain that view to this day!

The day we have the chance to share a drink in Bloomfield, CT, I will recount many more stories that have enriched my worldview, along with the challenges I

believe Africa must overcome to find its place in the sun.

You asked if I have been vaccinated. Yes, indeed, I took both Pfizer doses in March and now feel the freedom to wade back into normalcy. I am eager to resume my pre-COVID activity – travel. I will be heading to East Africa for a couple of weeks and later this year to Europe for a few months. In between these trips, I plan to hit the road and explore parts of America I have not visited yet.

OMG, now I have to wonder: will Letter Five, which we eagerly anticipated, make its way to me? Would it make a difference if I pledged to respond within days of receiving your next letter?

I so look forward to hearing from you.

All the best,
Eric

Letter 5

June 28, 2021

Dear Eric,

It was indeed a pleasant surprise to hear from you. I had assumed that our "fun" COVID-19 activity had ended without us reaching our goal of five letters each. COVID-19 locked us in, prompting us into spaces within ourselves from where we wanted to share our thoughts, but after getting vaccines and regaining our freedom, life swiftly took over, leading to delays in our responses.

Where do I begin? The pandemic blues finally took a toll on me, coupled with fatigue and emotional exhaustion. Following the initial lockdown in the spring of 2020, I was among the few professors who taught in-person classes in the fall of 2020 and spring of 2021. As I told you in my last letter, managing a four-course semester was tedious. By the time I reached the end of the semester in May, I was wiped out. Then, I taught an intensive summer course every day for two weeks, condensing into a day what is usually covered in a week for a standard course. Remember I endured the four-course semester to earn extra money by teaching an overload

in the summer. While I got my wish, it took a toll on my body. Even though I plodded through it, I became lethargic, a feeling that many seem to experience at this time. In the second episode of "The Michelle Obama Podcast," Michelle Obama revealed that she's been "dealing with some form of low-grade depression."

However, I had to summon strength for my younger sister, who needed me. So, I tied my metaphoric "wrapper," like an African woman, and moved on. My sister was in the process of buying a house when she fell ill with COVID-19 in December 2020. Although she survived the illness, and successfully bought the home, she has become one of those labeled as "long haulers." This means she lives in daily dread of which post-COVID symptoms will consume her day. Fatigue is common and the brain fog is real. Going for lab tests and Magnetic Resonance Imaging (MRI) have become routine. I had to rush to Dallas to help her pack and move into her new home.

I took a brief break from the packing and moving to accompany my son to Berkeley, California, where he will be attending Berkeley Law in the Fall. This trip led me into deep reflection. I have been the sole parent to my two boys for 15 years now. They were 11 and 7 years old when I got divorced, and today, my older son just completed his first year at UPenn Law, while his brother is heading to Berkeley Law. They are now 26 and 21 years old, respectively. My older son completed a Master's degree before law school, but his brother is

skipping that step. It's been a long road. Both boys were active soccer players, which meant I spent Sunday to Sunday accommodating soccer practice and games all over the East Coast. I often drove from Connecticut to Maryland for games. Eventually, both boys played soccer at the highest level in American College athletics, Division I. My younger son, George, graduated as captain of his team at Boston University and won the John. B. Simpson Award for enthusiastic leadership.

When George graduated on May 16, 2021, it seemed all the energy I had been mustering up to raise my boys gave way. I became like a traveler who gathers all the energy to reach her destination and, upon arrival, collapses in exhaustion. Since then, I often find myself reflecting on the journey of raising my boys. The harvest looks bountiful, but I cannot deny some of what I lost in the process. I sacrificed a significant part of myself for us to reach this point. Nowadays, I find myself journeying within, searching for pockets of me that may have remained hidden from sight as the boys consumed my vision.

In this contemplative mood, I welcomed summer. I see people enjoying family parties and activities but I crave solitude. I yearn for the space for reflection. I have turned a corner in my life. I have reached the top of my career and successfully guided my two kids toward lucrative terminal career programs. I now face a new question: where do I go from here? What is my purpose? Have I attained it? I feel the answer in my spirit is a resounding

No! I have only scratched the surface, and there is a whole lot of me I have to leave on this earth before my number is called. So how do I transition into this next chapter, and what does it entail? I shared my thoughts with my older son, and the next day he shared a tweet posted on Twitter with me in which the writer asked, "Is anyone else in a weird transition period where they just don't know what to do with themselves?"

I realized I was not alone in dealing with this. Maybe the pandemic pushed many of us to a place where we are now forced to reconsider our purpose on earth.

This is one of the questions you grappled with in your last letter. You wondered why you were born in our part of the world, yet you have ended up spending over three decades in Uncle Sam's land. I could see that this question led you to not only look forward but also backward. You have partially answered that question by harnessing all that you have learned so far and packaging it into http://koryafrica.com. I visited the site and explored its pages. The potential for this communication enterprise is huge. COVID-19 gave you a gift that you will treasure for a long time.

Interestingly, the pandemic did not just compel you to look backward and harness all you have within, it also dared you to look forward and confront that beast that stares us in the face - the crisis in our homeland. You wrote, "I am also putting out an outline for how we bring peace back to English-speaking Cameroon based on a conversation I had with the late Cardinal Tumi."

What a mammoth task written in such simple prose and so understated! You know it is going to be more than putting out an outline. It is going to be putting out your life on a line outside to dry. Are you ready? No, this is not the proverbial censorship from those around you when you are trying to go big. It is a genuine question from one who understands your need to confront this moment. However, I know such a decision does not happen overnight. The burdens we carry! So much to say here: our lives as Africans and the burdens we carry. Yes, I repeated that deliberately. Our situation in Cameroon may be unique, but our burdens are no different from what I see in other African countries.

I understand that your experience at the World Bank certainly made you aware that true help can only come from within. That World Bank narrative is one that reverberated in my mind for days. I was hurt and outright angry. Yet, I could not pretend to be surprised. For those of us who have lived for more than two decades outside Cameroon and climbed the rungs of the professional ladder, we know those moments when we encounter subtle boundaries we are not allowed to cross, despite all the strides we have made. Those moments confirm our outsider status, even when, on the outside, we are considered veritable insiders. Ah!

Yes, I would love to see the letter before it goes out. You can count on me for whatever you have in mind, but the details of my involvement will remain a work in progress as you fine-tune your plans. Life is ephemeral,

and we can only hope that we are privileged with the opportunity to do more for our homeland than what we have already done.

Talking about how ephemeral life is, I guess I should tell you what happened to my sister, which I left out in my information about her buying a house. As she was about to wrap up the process of buying her house an unexpected tragedy occurred. Her real estate agent, an Asian, died as a result of a hit-and-run accident just a day before the final inspection of the house. Unaware of what had happened, my sister and her husband went to the house with the owner, waiting for the real estate agent to show up. It was unusual for him to be late. They called his phone several times, but there was no answer. Just as they started driving away, not knowing what else to do, a call came from him, but it was his son on the line, announcing his death. Apparently, he was walking with his wife near his house when an SUV veered off the road and hit him. The driver fled the scene.

My sister was devastated. She had worked with this man on different projects for over five years. Two hours before his death, he had texted my sister and her husband to remind them of the meeting the next day. The text message showed a 4 pm stamp, and per the police, he was hit around 6 pm that same day. How does one reconcile that? I was very concerned for my sister, given all she had been through and was still going through. Fortunately, this realtor's grown-up son is also a real estate agent. He and his mother rallied to complete the

deal, and my sister made sure the family got what was due to them. Fortunately, the hit-and-run driver was later arrested. See article here:

https://www.fox4news.com/news/keller-police-make-arrest-in-deadly-hit-and-run-from-lastmonth.

This death happened at a time in our adopted homeland when there is a rise in COVID-19 and "hate crimes" against Asians, and I could not help but think that this hit-and-run may be no accident. That's another topic we could explore all day!

Incidents like this remind us to seize the day and do what we can. This is also why I did not try to dissuade my sister when she and her husband decided to move on with the house purchase, even though she was not feeling very well. There is certainly no better time than the present for anything because tomorrow is not guaranteed. We just have to keep working with what we have in hand while waiting for better conditions to make improvements.

All this to say, move on with your project in Cameroon. Do your part when you can. I wish you all you need to bring out a salient road map for our country. You wrote, "My objective here is to enrich current conversations on what has been called the 'Anglophone Crisis.'" Maybe your "outline" should be in a book, no matter how slim. Something to think about.

Personally, I have committed to archiving our story in poetry, prose, drama, and even journal articles. I have done that in a couple of books and published book

chapters. As Achebe succinctly put it: "It is only the story...that saves our progeny from blundering like blind beggars into the spikes of the cactus fence. The story is our escort; without it, we are blind."

I felt the urgent need to do this a long time ago when I was studying for a Master's Degree in Library Science at the University of Wales, Aberystwyth, now the University of Aberystwyth. It was the first time I was studying away from Cameroon, and as a librarian-in-training, I was curious to see how my country was represented from the outside. As I have written elsewhere:

"It is during this time that I became aware that Anglophone Cameroon was largely undocumented. Each time I looked up Cameroon in reference sources, it was identified as a French-speaking country.

Anglophone African countries were Ghana, Nigeria, Sierra Leone, Zambia, Kenya, etc. Anglophone Cameroon was lost." This was in 1989/1990, and I decided that I would make a modest contribution to "nation building" by documenting Anglophone Cameroon for posterity. Therefore, I was already "woke" when I returned to Cameroon in 1991 to witness the rise of Anglophone nationalism. I have stayed "woke" on this topic, but unfortunately, we have reached a point where the narrative has been hijacked by a few persons who do not know how to build a consensus or find common ground. The "all or nothing" position has left our people vulnerable to kidnappers and killers. We are now at the

mercy of barbaric news headlines as we remain helpless.

This is another indication that alternative narratives are needed so we can achieve what the venerable Achebe called "The balance of stories," which Chimamanda Ngozi Adichie further amplified in her TEDTalk, "The Danger of a Single Story." Yes, I am a sucker for Chinua Achebe. The man was wise. The best of Chinua Achebe can be found in his essays. Once again, I recommend them to you, so you can add them to your library if you have not yet done so. There are a couple, including *Morning Yet on Creation Day, Hopes and Impediments,* and *Home and Exile.* You will find even his memoir on Biafra, *There Was a Country,* illuminating in the light of our struggles. So much to say, and this medium is simply not adequate to capture it all. Someday!

So, you are vaccinated and free to resume travel, eh? Are you back from East Africa? How was it? I am stuck in the USA for the summer. I have taken my vaccinated self to Dallas, (Texas), Berkeley, (California), and Philadelphia, (Pennsylvania). All utilitarian trips in my role as parent or sibling. I look forward to at least one trip to restore my soul. I don't yet know what that would entail. I did the stupid thing to allow my passport to expire during the pandemic and did not realize the backlog that would happen after the lockdown. I sent my passport for renewal on May 4, and it only entered the processing phase on June 7th and I will only get it 12 weeks from that day. And so it is that, for the first time in my life in close to 25 years, I am going to spend more than a year

without traveling out of the USA.

Well, Eric, there's so much to say and so many stories to share beyond the written word. Yes, we will have the opportunity to share a drink in Bloomfield CT, or somewhere else under God's blue sky. Inshallah! In the meantime, be well and remain blessed. I trust you will keep your "pledge" to get back to me "within days of receiving" my letter.

I look forward to your fifth letter and our final in the series.

So long!
Joyce

Reply to Letter 5

July 14, 2021

Dear Joyce,

I am starting this letter – Letter Five!!! – at this ungodly hour of almost 4 am just so it will stay in my spirit, and I will take it up as a matter of priority after I wake up. That's my hope.

Here I am, over a month later, picking up where I left off in July. Today is August 27!!! I always thought, after leaving active service in the World Bank, and all the other formal places of work, that I would someday be retiring into the quietude of placid living, far away from the madding crowd. No peace for the weary, right? The past few months seem to have compelled me to make up for the breezy days of the lockdown during the 2020 pandemic.

I turn my attention now to something of a heavy heart to what may be the last letter in our COVID-19 exchange. This ought to be just another chapter in the long story of a short but intense era; not the last lines of an exciting venture that led us, as you so aptly remarked, to "truths that are barricaded in the fragile parts of our being." I proceed in the hope that we will find a way to

keep this river of thought flowing long into the future.

We did engage in some exploration of the inner reaches of our being, looking to find the purpose that would give meaning to life on this side of heaven. You explored the years that saw you singularly focused on bringing up your boys and taking them to a place where you could step back and gleefully contemplate the road covered. The harvest looks bountiful, you said with obvious satisfaction, but this was not what it was all about. You clearly hinted, having scaled one hill, that there were more mountains to climb; that there had to be more to life than successfully bringing up the boys! Again, you put it so succinctly: "…the pandemic pushed many to that place where they are now forced to rethink their purpose on earth."

The search for Purpose! That is clearly where the introspection in our correspondences has been leading us, right? We have revisited some highlights of times past, recalled some ignorant acts in the age of innocence, relived some good and not-so-good moments of yesterday, and shared the threads that make up the tapestry of a life that ultimately brought us to this pandemic lockdown. I wonder now: does it all contribute to a definition of Purpose or must we incorporate all that lies ahead to ultimately define our *raison d'être* for being? Is purpose in the end-game or is it in every action and inaction that together constitute the art of living?

Where do my years – and yours – in these United States of America fit in? How do they add, individually

or collectively, to our purpose? I came here in the late seventies as a student, lived happily with my *white* American "parents" and attended what was a mostly *white* school in upstate New York. I recall the Sunday when my parents, Bill, and Ruth Hall, had to make the case for me to be let into a *white* Methodist church to pray with the all-*white* congregation; I remember the day when my musician "brother" Doug had to argue and stand his ground before I was allowed into the club where he was scheduled to play that night before a mostly *white* crowd of yuppies. I was one of the best students in my university class and I remember being told that our somewhat confused faculty dean had explained this by the fact that I was a "prince" from Africa who had been exposed to a very high quality of education. How else was he supposed to figure out this anomaly? I visited the small town of Rye, New York, during one of the breaks from school and, left alone when my hosts Diana and her mother went out the next morning and suggested I take a bicycle ride around the neighborhood, found the house surrounded by a full contingent of the Rye police force. They had been told a dangerous stranger had just been seen entering Mrs. Moxhay's house.

I recount these things because I did not think much of them at the time; I easily put everything in perspective and just as easily put them out of my mind. It would be forty years, with the arrival of Donald Trump to the White House and our COVID-19 introspection, before I would slow down enough to see the ugly underbelly

of America and re-think all those episodes of my past in this once beautiful country. Bill and Ruth have since passed on but I cherish every moment I spent with them and in the America they introduced me to; I love Doug and his two sisters, Jane and Kris, with the same brotherly passion I felt forty years and more ago. I see America differently now and I do not like what I see. Now I am forced to ask myself where the God is that this country recognizes in its constitution and prays to every day. Black, white, and brown have taken on a whole new meaning for me in America. As have the words "colored" or "people of color" and the despicable connotations that come with them – as they once did in apartheid South Africa. When did America become that? Trump could not have introduced hate, xenophobia, and the rejection of the *other* that suddenly seems to be so prevalent in society and the body politic of this country, I surmise! That must have always been lurking just below the surface, right? He simply exposed it, I think.

Until now, I had no problem with my two American-born kids fully identifying with the land of their birth; the two who were not born here have since naturalized. Should I have regrets about this or must I consider their nationality a part of their journey as they too engage in their search for purpose? I do not know hate and cannot teach them how to recognize or deal with it. I do not see white, black, or brown as I walk the streets of Fairfax, my city. I do not fear the *other* or change direction when approaching folks who do

not look like me. I see in each one a child of God and I marvel at the diversity and the beauty of it all. I have had time, over these COVID-19 months, to reflect on that, wondering if this is a case of extreme naïveté or the product of a deeper appreciation of our common humanity.

I have often contemplated the idea of permanently returning to the land of my birth, Cameroon. However, I find myself pondering the nature of the country I would be returning to. In the early 80s, I returned home after my studies in the US with the aspiration of contributing to the development of our relatively new nation. During that time, I had the exciting opportunity to play a role in the birth of one powerful tool of social transformation in the country – television! I did not take anything for granted. I always wondered how we could use television to make this spot on the planet a better place for all who inhabit it. I initiated and launched a wide variety of programs spanning health, education, culture, and sports; the aim being to move the social mindset from mere consumption to active production. At one time, it appeared like this would constitute my life's work. However, in a little over five years, I found myself being uprooted once again from Cameroon by powerful forces beyond my control. For the majority of the last three decades, I have operated out of an address in the United States, extensively traveling the world and discovering the magnitude of the universe in which we live.

Among the numerous things that captured my

attention and the innumerable lessons I've learned, I find myself unable to process the two predominant forces that seem to drive existence on our planet today, namely, money and power! It is still unclear to me why people seek both with unwavering dedication, especially in the context of my country and continent. I know all the easy answers, as you can well imagine, but none of them quite leads me to "purpose"! The question is: Can the mere accumulation of money and power serve as the ultimate purpose of one's life? You may be able to give me some analytical elements that elude my understanding.

As I slowly and quietly transition into the sunset years of my time on earth, I am conscious of the not-too-distant rendezvous with my maker. Soon, I might be confronted with the need to provide an answer to the inevitable question: *What did you do with all I gave you?* Contemplating this fact, I wonder if it matters that I did not chase after money and power, or that I lived fairly comfortably in a world wracked by disease and poverty. Will I discover, standing before God, that a life characterized by moderation and empathy was a fitting leitmotif for the time and resources bestowed upon me when I came into the world? Do I still have time to fine-tune the answer I must give when I stand in judgment at the Pearly Gates?

Joyce, you can see what predominant thoughts occupy my mind each morning when I wake up to a new day! It is unclear to me if we are still in the grip of the pandemic or already in the post-COVID era. I have

been thrust into this space within myself, as you aptly put it. I feel I must pursue what I believe is my purpose – the sum-total of the everyday things I do to deserve a place beside God in the Afterlife. How about that?

Shall I hear from you soon or must I wait? I understand this is the final letter in the series, but as I wrote earlier, I hope we will find a way to keep this river of thought flowing long into the future. Well, I know the pressures of enriching young minds would grow exponentially on any university professor at this time and I'll understand if I have to wait months to hear from you. Maybe weeks?

I hope all goes well for you and your students in the new semester.

Keep well and stay safe.

All the best,
Eric

Postlude

By the time we ended our letter-writing project on August 27, 2021, humanity had experienced a sobering lesson from COVID-19. On this date, in the state of Virginia, where Eric lives, COVID-19 fatalities had reached 11,769; in my state of Connecticut, the toll was 8,355; and across the United States, the deaths, confirmed and probable, stood at a staggering 172,857. It is still hard to wrap one's head around these numbers. In contrast, the narrative in our homeland, Cameroon, and the wider African continent, differed significantly. The death toll was not the *tsunami* the Western world had predicted.

The global media, however, remained relatively silent on one of the most significant stories that should have come out of the 2020 COVID-19 experience: the relatively low death count on the African continent. As hundreds of thousands were dying in the Americas, Europe, and Asia, the pandemic came across as just another disease in search of a solution in Africa. Masks

and vaccines from America, often available in limited quantities to a corrupt leadership class, quickly became the sources of cruel jokes by the indifferent masses.

It appeared that no one, particularly Big Pharma, the international pharmaceutical cabal that controls this industry worth trillions of dollars annually, was willing, it seemed, to seriously consider what was unfolding in various parts of Africa. Contrary to fears (or perhaps hopes) entertained by some international organizations, people were not collapsing in the streets across the continent.

In Madagascar, President Andry Rajoelina made headlines by announcing a herbal remedy that seemed to be making a positive impact in combatting the disease in his country despite dismissive howlings by international actors. It was developed by the Malagasy Institute of Applied Research (IMRA), which had been studying a common anti-malarial herb, *artemisia annua*, which had shown promising signs in the treatment of SARS, the Severe Acute Respiratory Syndrome, another respiratory disease caused by coronavirus.

In Cameroon, Monsignor Samuel Kleda, a senior Catholic prelate, successfully treated people who had contracted the disease and were on the brink of death, using a plant-based treatment. Dr. Eluem Blyden, a molecular geneticist originally from Liberia, collaborated with a group of African scientists to launch the "Mother of Birds Initiative," which produced vaccines from hens, based on a novel vaccine platform that combines traditional egg-based technology with new, cutting-edge

science, using another virus as a building block.

The Big Pharma-controlled media readily spoke of untested remedies, quickly reported the "sharp rebuke" from the World Health Organization (WHO), and the dismay with which the medical community had received news of the "cures" from Africa. People were not dying from COVID-19, at least, not in numbers remotely close to what was expected!

By August 27, when Eric wrote his fifth and final letter in our series, we were fortunate to have received the protection of vaccines against the virus. However, the letters had opened up internal spaces that could no longer be sealed off. Eric aptly expressed this when he said, "We did engage in some exploration of the inner reaches of our being, looking to find the purpose that would give meaning to life on this side of heaven." I echoed a similar sentiment in one of my letters in which I stated that "…the pandemic had compelled many to that place where they are now forced to re-evaluate their purpose on earth." The question lingered: Did we discover our Purpose? Was it something we found even before the pandemic? If so, how can we be certain? Eric was getting to this when he asked, "Is purpose in the end-game, or is it in every action and inaction that together constitute the art of living?"

In some ways, the stories unearthed in our letters showed that we had encountered unique experiences and may have fulfilled some of our Purpose unbeknownst to us. In threading and rethreading the needle of the past,

we could now see a more extraordinary design in some of our experiences.

In that final letter, the last in our series, Eric said, "I proceed in the hope that we will find a way to keep this river of thought flowing long into the future." However, by 2022, the mutual river of thought had dried up as we returned to our busy lives and numerous projects.

Then came 2023, and we found ourselves on a health lockdown, reminiscent of a scene from a movie. Not too long ago, during the initial COVID-19 lockdown, we exchanged letters with what I now call the "arrogance of the healthy." COVID-19 was raging, but since we were not sick, we could afford the luxury of digging back into our lives as we coped with the pandemic. Then, in under two years, the tables turned, and both of us faced acute illnesses. Once again, we reconnected during our treatment and recovery period, reigniting the "river of thought." This time, however, it emanated from a place of vulnerability. We were situated on the precipice of life, aware that anything could happen. It was a sobering reality that did not frighten us but instead energized and enriched our discussions.

From this vantage point, the exploration of purpose took on an even more prominent role. During one of my many trips to the hospital, I stopped at the hospital gift shop and found a book, *Dangerous Faith: 50 Powerful Believers Who Changed the World*. I browsed through it and was fascinated by some of the profiles. The lives profiled were instructive. I purchased a copy for myself and

ordered one for Eric. As we delved into the stories, we realized that our country and continent needed similar profiles to be spotlighted.

I was still undergoing treatment when I invited Eric to join me in interviewing a historical figure in Cameroon, a crucial step toward writing the individual's biography. Through Zoom, we conducted 22 hours' worth of interviews. Time was of the essence. We were seeing the world with even fresher eyes. That project is still ongoing.

The plan is to sustain that shared mutual "river of thought flowing long into the future." Hopefully, some fragments of our life's Purpose are embedded within its currents.

At the end of it all, our collective hope is to leave this world better than we found it. In sharing our thoughts through these letters, we hope we have ignited your thoughts about your sojourn here on earth and what that means for you as a human being. If we manage to prompt just one person to reflect along these lines, we consider it the fulfillment of the *raison d'être* behind publishing these letters.

Thank you and stay blessed!
Joyce Ashuntantang

About the Author

Joyce Ashuntantang (Joyce Ash) is a poet, actress, interdisciplinary scholar, and Professor of English at the University of Hartford, Connecticut. A graduate of universities on three continents, Dr. Ashuntantang received a BA in English with a minor in Theater Arts from the University of Yaoundé, Cameroon, a Master's in Library and Information Science from the University of Aberystwyth, UK, and a Ph.D. in English/African Literature from the City University of New York. She is the author of many scholarly and creative publications, which include *Landscaping Postcoloniality: The Dissemination of Cameroon Anglophone Literature* (2009),

Routledge Handbook of Minority Discourses in African Literature, coedited (2020), and four poetry collections, *Their Champagne Party Will End: Poems in Honor of Bate Besong*, coedited (2008), *A Basket of Flaming Ashes* (2010), *Beautiful Fire* (2018, Arabic trans. 2024) and *Bearing Witness*, coedited (2020). *Beautiful Fire* won the prestigious African Literature Association (USA) Book of the Year Award – Creative Writing (2020).

She has appeared as an invited poet in many countries worldwide, including England, Germany, Nicaragua, Greece, Costa Rica, Colombia, Bangladesh, Cameroon, and the USA. She has also contributed to several international anthologies of poetry, including *Peace for Afrin, Peace for Kurdistan* (2019), *Hiraeth-Erzolirzoli: A Wales-Cameroon Anthology* (2018), *Poems for the Hazara* (2014), *Reflections: An Anthology of New Work by African Women Poets* (2013), and *We Have Crossed Many Rivers: New Poetry from Africa* (2012). Her poems have been translated into Spanish, Greek, Hebrew, Turkish, Bangla, Arabic and Romanian. Her Awards include the Spirit of Detroit Award for Leadership (1987), Ministry of Culture, Cameroon, Award for Outstanding Performance in Theater (1989, 1994), Belle K. Ribicoff Prize for Excellence in Teaching and Scholarship (2012), Kathrak-Bangladesh Literary Award (2018), the Pan-African Ivory Club of Tampa Educator award (2018), and the President's Service award for outstanding volunteer contributions in community service to the United States (2024). Professor Ashuntantang is also

a community leader dedicated to empowering women and girls to reach their full potential. She is the vice president of the African Women Summit, Cameroon chapter, and president of the all-female Ex-Saker Students Association in the USA.

About the Author

Credit: author

Eric Chinje is a Cameroonian-born and raised Communications and Media expert. He is also a visiting scholar at George Mason University in Fairfax, Virginia. Fluent in English and French, Mr. Chinje studied at the universities of Yaoundé (Cameroon), Syracuse (New York), and Harvard (Cambridge, Massachusetts). He has held leadership positions in local and international organizations based in Washington, Tunisia, London, Nairobi, and Yaoundé, including Chief Executive Officer of African Media Initiative (AMI), Senior Adviser at KRL International, Director for Strategic Communications at the Mo Ibrahim Foundation, World Bank's

External Relations Manager for Africa, Head of External Affairs and Communication unit at the African Development Bank, Editor-in-Chief of Cameroon Television and a contributing correspondent for CNN World Report, and a stringer for the BBC World Service, Voice of America, and Deutsche Welle Radio. He served as an Adviser to the governments of the Democratic Republic of Congo (DRC), Liberia, and South Sudan on their strategic, development, and international communications - an extension of his role as a Senior Advisor at the Washington-based International Communications and Relations firm, KRL International. After formal employment, Mr. Chinje's attention has turned to civic and philanthropic endeavors. He volunteers for these worldwide, especially in his home country, Cameroon. Mr. Chinje has received many prestigious awards and recognitions, including a lifetime achievement award for audio-visual communication from the ICT University Cameroon (2023) and a Man of the Year award from the Pan-African Ivory Club of Tampa, Florida, USA (2023). He is an Officer of the Cameroon Order of Merit and an Officer of the Dutch Order of Orange Nassau.

About the Publisher

Spears Books is an independent publisher dedicated to providing innovative publication strategies with emphasis on Africana stories and perspectives. As a platform for alternative voices, we prioritize the accessibility and affordability of our titles to ensure that relevant and often marginal voices are represented in the global marketplace of ideas. Our titles – poetry, fiction, narrative nonfiction, memoirs, reference, travel writing, African languages, and young people's literature – aim to bring African worldviews closer to diverse readers. Our titles are distributed in paperback and electronic formats globally by African Books Collective.

Connect with Us: Go to www.spearsbooks.org to learn about exclusive previews and read excerpts of new books, find detailed information on our titles, authors, subject area books, and special discounts.

Subscribe to our Free Newsletter: Be amongst the first

to hear about our newest publications, special discount offers, news about bestsellers, author interviews, coupons and more! Subscribe to our newsletter by visiting www.spearsbooks.org

Quantity Discounts: Spears Books are available at quantity discounts for orders of ten or more copies. Contact Spears Books at orders@spearsmedia.com.

Host a Reading Group: Learn more about how to host a reading group on our website at www.spearsbooks.org

www.ingramcontent.com/pod-product-compliance
Lightning Source LLC
Chambersburg PA
CBHW022105160426
43198CB00008B/362